AERNOUT
MIK

AERNOUT
MIK

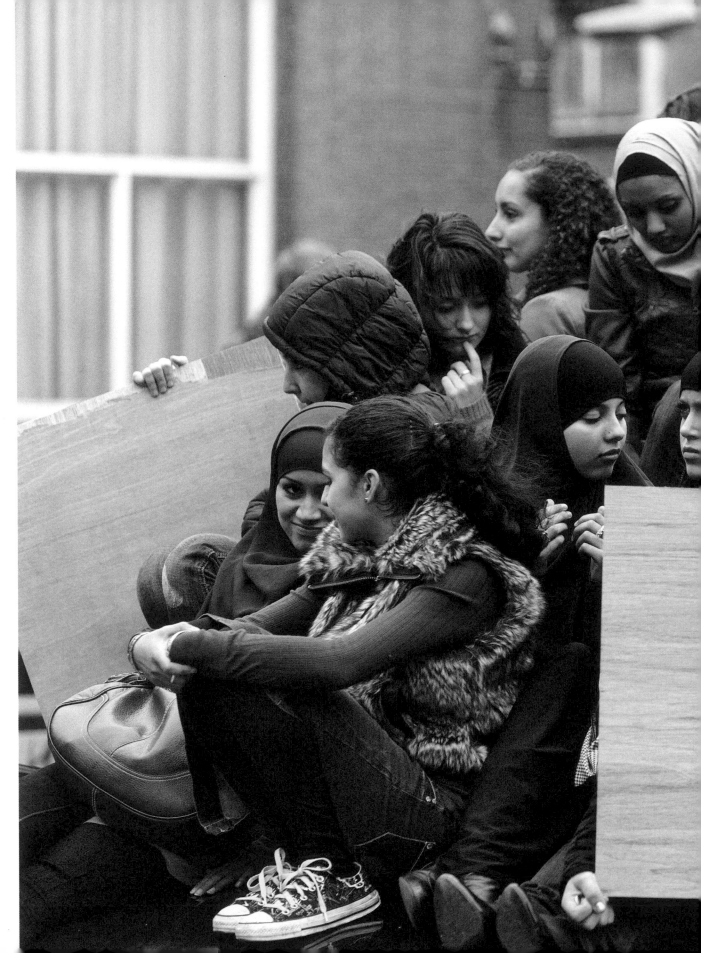

Published on the occasion of the exhibition *Aernout Mik*, May 6–July 27, 2009, at The Museum of Modern Art, New York, organized by Laurence Kardish, Senior Curator, Department of Film.

The exhibition is made possible by The Contemporary Arts Council of The Museum of Modern Art and the Mondriaan Foundation, Amsterdam.

Additional support is provided by The International Council of The Museum of Modern Art in honor of M. Joseph Lebworth and by The Consulate General of The Netherlands in New York.

Produced by the Department of Publications
The Museum of Modern Art, New York
Edited by Libby Hruska
Designed by Pascale Willi
Production by Christina Grillo
Typeset in Adobe Caslon and Univers
Printed and bound by Oceanic Graphic Printing, Inc., China
Printed on 140 gsm IKPP Woodfree

Library of Congress Control Number: 2008942326
ISBN: 978-0-87070-742-1

Published by The Museum of Modern Art
11 West 53 Street, New York, NY 10019-5497
www.moma.org

Distributed in the United States and Canada by D.A.P./Distributed Art Publishers, 155 Sixth Avenue, 2nd floor, New York, NY 10013, www.artbook.com

Distributed outside the United States and Canada by Thames & Hudson, Ltd, 181 High Holborn, London WC1V 7QX, www.thamesandhudson.com

Cover: Still from *Training Ground*. See p. 72
Pp. 4–5: Set Photograph from *Schoolyard*. See p. 80
P. 8: Still from *Vacuum Room*. See p. 50

Printed in China

All works by Aernout Mik © 2009 Aernout Mik

Pp. 28, 34, 42, 50, 54, 62, 72, 81: Drawings by Aernout Mik showing installation views of each work in the exhibition at The Museum of Modern Art

Credits
Courtesy the artist and carlier | gebauer, Berlin: 12, 24; BFI Stills: 27; Film Stills Archive of The Museum of Modern Art: 18; courtesy Ernst Moritz: 63; courtesy Axel Schneider, Frankfurt am Main: 35; courtesy Raimund Zakowski: 55

CONTENTS

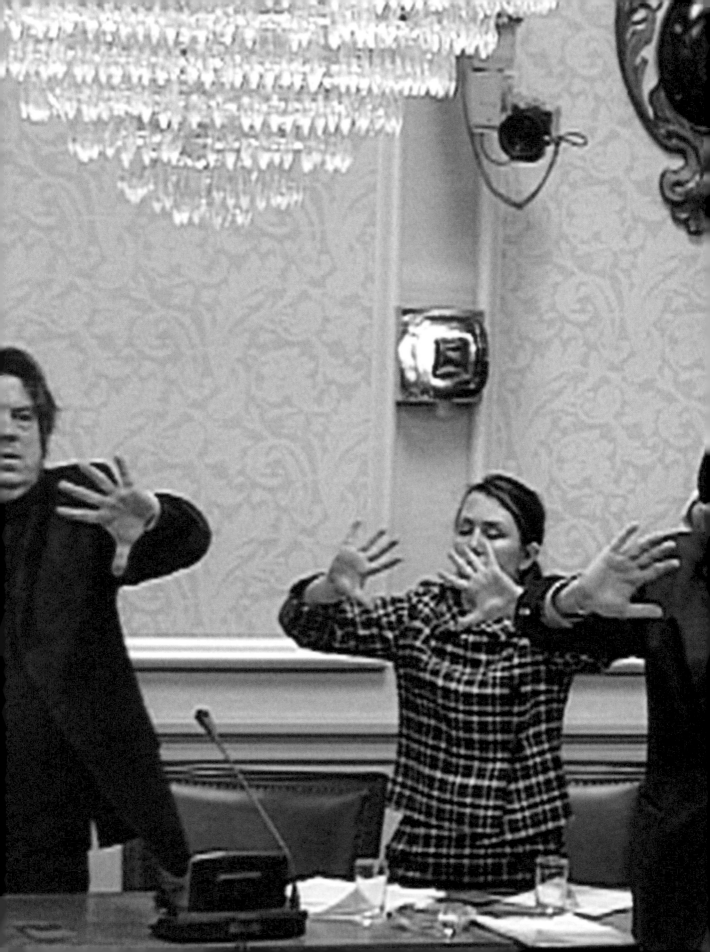

FOREWORD

One exciting aspect of contemporary art is the plasticity of its practice. Artists combine, shift, and transform disciplines to make works that ask us to reconsider traditional modes of presentation. This is certainly true of Aernout Mik, the internationally acclaimed Dutch artist whose innovative installations integrate moving images, sculpture, and architecture. This exhibition, the first survey of the artist's work to appear in North America, presents a selection of moving-image pieces made over the past thirteen years, beginning with *Fluff* (1996), Mik's first filmed work, to *Schoolyard* (2009), which was commissioned by the Museum.

Mik's works vividly capture the zeitgeist of our fractious world. His installations never announce but always imply current issues, from economic crises and immigration struggles to parliamentary clashes and outright warfare.

Although his imagery appears to document actual events, it is often fully staged by the artist, who challenges viewers' systems of belief and invites them to ponder relative degrees of reality.

I extend my sincerest thanks to The Contemporary Arts Council of The Museum of Modern Art and to the Mondriaan Foundation, Amsterdam, for their generosity in making this exhibition possible. I am also indebted to The International Council of The Museum of Modern Art, whose contribution in honor of M. Joseph Lebworth helped support this exhibition and catalogue. My thanks also go to The Consulate General of The Netherlands in New York for its assistance. I wish to thank Laurence Kardish, Senior Curator in the Department of Film, for organizing such a surprising and unusual exhibition. Working closely with the artist, he selected both traditional galleries as well as public, non-gallery spaces within the Museum to install the works. These interstitial areas posed a particular set of challenges but also provide unexpected rewards. His essay included here gives an incisive overview of Mik's artistic practice. I am also grateful to Michael Taussig, Professor of Anthropology at Columbia University, for contributing his perceptive response to Mik's work.

Finally, I am grateful to Aernout Mik, who has been involved with virtually every aspect of the exhibition. His enthusiasm, intelligence, and generosity have been critical to all facets of this project.

Glenn D. Lowry
Director, The Museum of Modern Art

ACKNOWLEDGMENTS

Throughout the organization of *Aernout Mik* I have been fortunate to work with many dedicated and excellent individuals and teams within the Museum who have contributed enormously to the exhibition and catalogue.

I am most grateful to Glenn D. Lowry, Director, for his constant support, enthusiasm, and guidance. I warmly thank Mary Lea Bandy, former Chief Curator of Film and Media; Rajendra Roy, Celeste Bartos Chief Curator of Film; and Klaus Biesenbach, Chief Curator of Media, for their encouragement.

I also owe a great debt to Kelly Sidley, Curatorial Assistant, for her inestimable and wise contributions to both the exhibition and catalogue. We were truly partners in this endeavor.

The organization of this exhibition would not have been possible without the support, understanding, and keen professionalism of Jennifer Russell, Senior Deputy Director for Exhibitions, Collections, and Programs; Peter Reed, Senior Deputy Director for Curatorial Affairs; Jerome Neuner, Director, and Lana Hum, Production Manager, Exhibition Design and Production; Charlie Kalinowski, Media Services Manager, Information Technology; and Allegra Burnette, Creative Director, Digital Media.

I would also like to thank Jennifer Manno, Assistant Coordinator of Exhibitions; Kim Mitchell, Director, and Margaret Doyle, Associate Director of Communications; and Claire Corey, Production Manager, Graphic Design. Special thanks go to Howard Deitch, Mike Gibbons, and the entire audiovisual team for their help with the installation.

For helping to make this exhibition and catalogue possible, I am grateful to Todd Bishop, Director, and Mary Hannah, Associate Director, Exhibition Funding, who did a splendid job. I also thank Maggie Lyko, Director, Affiliate Programs; Emily Brouwer, Senior Program Coordinator, The Contemporary Arts Council; Jay Levenson, Director, The International Program; and Carol Coffin, Executive Director, The International Council, all of whom helped find supporters. The generosity of The Contemporary Arts Council and The International Council of The Museum of Modern Art is deeply appreciated. I am doubly delighted that The International Council's gift was made in honor of M. Joseph Lebworth, a longtime friend of the Department of Film.

Major support for this exhibition has come from two generous foundations in The Netherlands. I am most grateful to the Mondriaan Foundation and The Netherlands Foundation for Visual Arts, Design and Architecture. Additional support is provided by The Consulate General of The Netherlands in New York.

In the Department of Publications I thank many individuals for their enthusiastic and astute support through all phases of this volume's production: Christopher Hudson, Publisher; Kara Kirk, Associate Publisher; David Frankel, Editorial Director; Libby Hruska, Editor; Marc Sapir, Production Director; Christina Grillo, Production Manager; and Hannah Kim, Marketing and Book Development Coordinator. I owe special thanks to Pascale Willi, who designed this handsome book, and to Michael Taussig for his insightful essay.

There are many colleagues within the Museum who have discussed this project with me and helped shape the exhibition. In particular, I thank Jytte Jensen, Josh Siegel, and Sally Berger in the Department of Film, and Barbara London in the Department of Media.

I am particularly pleased to be able to enrich this exhibition with a strong educational component. For making this possible, I thank Wendy Woon, Deputy Director for Education; Pablo Helguera, Director, Adult and Academic Education; and Laura Beiles, Associate Educator.

In considering Aernout Mik's career, I consulted the work of other curators and writers whose exhibitions and articles informed my ideas about the artist. I would like to acknowledge Dan Cameron, Bruce Haines, Maria Hlavajova, Jenni Lomax, Stephanie Rosenthal, Ralph Rugoff, Dennis Scholl, Marion Boulton Stroud, and Hester Westley for their appreciation of Mik's work. I also want to thank Jillian W. Slonim for her ideas and encouragement of this project. I especially thank Stuart Klawans for his thoughtful comments on this publication's essays.

I was privileged to have the support of Mik's two galleries: Marie-Blanche Carlier and Ulrich Gebauer of carlier | gebauer in Berlin and Christian Haye of The Project in New York provided me with essential documentation. Thanks are also due to Daniel Kerber at carlier | gebauer for his invaluable assistance.

Finally I would like to offer my most sincere appreciation to Aernout Mik, with whom I collaborated on this project. It was very rewarding to work with an artist who was so free with his time and ideas, and whose works, I believe, are so significant.

Laurence Kardish
Senior Curator, Department of Film

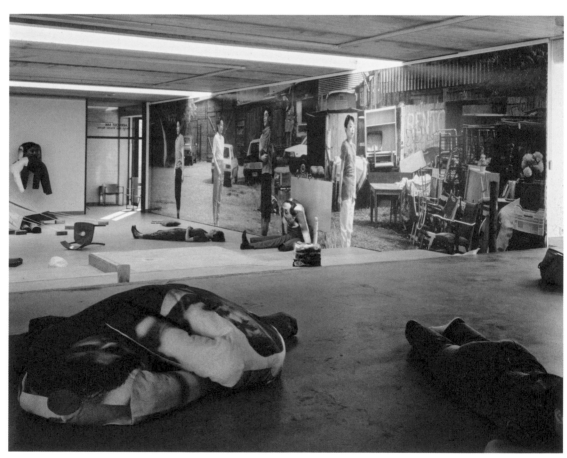

Fig.1. **Aernout Mik.** *Für nichts und wieder nichts*. 1992. Installation consisting of life-size dummies constructed from photographically printed linen, wallpaper, and found and constructed objects. Installation at Deweer Art Gallery, Otegem, Belgium, 1992

LAURENCE KARDISH

AERNOUT MIK:
AN INTRODUCTION

Contemporary art often resists taxonomy. Not only are technological developments quickly positing new modes of electronic expression but the concept of art has become so broadened that the most basic of actions—say, a walk across a room—have come to be considered art-making. Perhaps more than ever before, artists, with the pluck of their vision and the abandon that comes with the act of creation, jump mediums, incorporating what were once thought distinct and separate practices into novel works. The contemporary artist claims territory whose expanding frontiers are not only fluid but in constant and ferocious process.

Aernout Mik is an artist who exemplifies the fluidity of boundaries. His moving-image installations, situations, constructs—rich in allusion and subversive of codes—not only meld filmmaking, sculpture, and architecture into a unity that is at once compelling, unsettling, and original, but in their canny treatment of actuality interrogate such basic ideas as narrative and reality. Mik does not simply make films; rather, his motion pictures are integral—necessary but not sufficient—to what he does make. Mik designs, sculpts, and builds constructions that both hold his moving images and engage the physical body of the spectator. The works require a kinesthetic relationship with the viewer, who absorbs three essential things: the unlikely geography of the piece, the curious nature of the structure itself, and the compelling images that occupy the volume Mik has created.

Although interested in the making of art from an early age, Mik studied law and philosophy before entering the art school Academie Minerva, in his hometown of Groningen, The Netherlands. There he was influenced by one teacher in particular, British sculptor Thomas Puckey, half of the pioneering performance duo Reindeer Werk. Together with Dirk Larsen, Puckey had created installations of sculptural conjunctions in which behavior was a key component. Mik began his career by "directing" works that not only included these elements but coupled them with physical and perceptual distortion. In his early piece *Für nichts und wieder nichts* (fig. 1) Mik scattered soft, headless dummies, whose torsos were printed with photographs of faces, and various objects in an interior space silently occupied by performers and on whose walls were pasted larger-than-life photographs of people posed outdoors.

In these pre-film performance works odd but not completely inappropriate things happen in spaces where other activities usually take place. Mik's disjunctions are relational, not radical: something is always askew or off balance, awkward, even absurd, but never ridiculous. In 1993, for instance, the artist transformed a room off a corridor in a Utrecht conference center into a dormitory, with six beds occupied by sleeping people as well as hamsters in cages. Visitors to the center were surprised to find both recumbent humans and busy rodents. Should the sleepers be disturbed? The hamsters given water? What are they doing there? Yes, conference attendees might need to sleep, but why the hamsters? In *Project for La Vie Conference Center, Utrecht* Mik lets the viewer surmise the connection and, in doing so, invites the viewer to exercise his imagination.

In another example of an intervention in public space, in 1995 Mik created a deviation within one of the galleries of the Stedelijk Museum in Amsterdam. In addition to the guards who would ordinarily be present to watch and protect the works

of art, Mik populated the space with "fake" guards—extras in guards' clothing—who were completely disinterested in their presumed duties. The uniformed performers read comic books, rested by a table, conversed with one another, and seemed oblivious to the headless mannequins and clothes scattered in the gallery. Visitors to the exhibition, titled *Blue Sinkhole*, experienced a perceptual and psychological double take. Who is real and who is not? Wouldn't some of the "real" guards be as detached from the exhibition as the "fake" ones? Isn't it strange that one group, the "real" guards, are in fact doing their job by keeping safe another group, the "fake" guards (part of the artwork), from yet a third group, the public? Jaap Guldemond has written of Mik's unsettling use of space: "[It makes the visitor] aware of the artificiality and thus interchangeability of various agreements and rules to which he continually and unconsciously subjects himself practically everywhere....Much of Mik's work plays with the idea of breaking open this regulated, often unconscious behaviour."[1]

In a conversation I had with the artist, Mik said,

I was always interested in bodies in space and the presence of bodies in space and this, of course, is a sculptural starting point. But when I was working with this idea my interests developed more and more in the idea of installations, or, as I would call them, "situations" where constellations of people or of different living creatures and objects meet in space....I was doing things within shows which would be built out of different components, and these components formed these situations. It was a very, very short step to filming these constellations because film is a report of, let's say, a constellation of people, objects, and space.[2]

Mik's very short step led to *Fluff* (1996; p. 28), one of his earliest films.[3] Shot on super 16mm film with a stationary camera, the action takes place, like that of the earliest works of cinema, within a single fixed frame. But, unlike these primitive works, *Fluff* sports several sudden cuts: action is abbreviated, movement aborted. It is a type of editing, seldom used in narrative cinema, with which Jean-Luc Godard electrified audiences watching his first theatrical feature, *Breathless* (1960). In *Fluff*, however, there is no story. Just as viewers can begin to posit a tenuous understanding of the relationships between individual performers, Mik's jump cuts disappear both performers and relationships. Performers may suddenly reappear, but not where they went missing. The action happens in a room, perhaps that of a warehouse or even a stage set, with chairs and sofas covered in plastic. On a table sits a human head (one of Mik's signature "real-looking" dummies). People wander in and out of the room, some drop their trousers, some take off their shirts, some sit—and all are assaulted by bits of goo flung onto them from outside the frame. The space they inhabit seems to come with its own strange weather system. No one appears the least bit perturbed. The action is just weird, and the performers remain unreactive and uninflected.

Fluff may be viewed on a monitor—it does not require the specially constructed screening surface that has become a critical component of the artist's work ever since. Mik applies a heterogeneous view of space when it comes to how and where he exhibits his subsequent moving-image pieces. This approach tends to exclude gallery areas within museums, where the static contemplation of art is traditionally sought, in favor of areas usually reserved for foot traffic. The appearance in corridors and passageways of Mik's works surprises and arrests the viewer who engages not only with the piece itself but with the comings and goings of fellow viewers. To experience a Mik piece is to be aware of other presences, of being part of a group, an ephemeral and evanescent community like those depicted in the works themselves.

Just as the kinetic presence of other viewers plays a role in his art, Mik also makes "extras" of his public. Though he

cannot choreograph his viewers, through the shape and size of his constructions the artist does determine to some extent where the viewer will stand and how his eyes will engage with both the images on-screen and the other observers. This provides a distinction between Mik's films and those shown in cinemas. In a theater the spectator may be aware of the bodily presence of others seated nearby, but the viewer, concentrating on the screen ahead and above, does not want his attention deflected by his fellow congregants' movements. In the cinema the spectators are expected to be passive, to receive, and to be overwhelmed by what is directly in front of them. They may react as a whole with communal laughter, gasps, and tears, but the crowd remains stationary. Mik's audience is of a different persuasion: it is a group distinguished by movement. The crowd changes—enlarges and diminishes—by the moment.

Mik envisions groups of people as "objects in space," as constellations. He charts the formation and transformation of groups, a metamorphosis that is a constant trope in his films. Groups appear, often seemingly opposed to one another and defined by costume, props, or placement within the frame. One group may seem to be more "in charge" than another: in Mik's films groups may mingle and intermingle, or they may disperse into an amorphous gathering, a crowd, sometimes to regather, reform, regroup.

Within any frame the movement of groups may be multiplane. Separate configurations move from foreground to distance, sometimes in loose parallel formations and sometimes through the entire field of activity. In recording these movements Mik keeps the whole field in sharp focus so that no group is visually privileged and all activity is equal. In this way he subverts the notion of depth with an elegance that at once flattens and questions the drama proposed by his moving images. Mik does not storyboard these intricate transactions before shooting. He conceives the setting and, in a very general manner, gives his cast a broad outline of the situation they are to portray.

The artist elaborates on this process:

It is always important to inform them and not inform them, so I hold back information because it is better for the way I work that they don't have a full image of what they are supposed to do. And since they are also not really very specific roles, no one knows really how different he is from the other and what exactly he represents. I don't give them too much information because I don't want them to become characters and to act....During the shoot, different qualities, different people emerge and become useful to what is coming to the surface....The prepared storyboard is basically the relationship between the different elements that are in the piece....In the shooting, I don't know when or exactly why what happens happens....It is collective action that's really going on. What always happens with people, even if they are completely unskilled, if you put them together in a certain situation and with certain general instructions, for the first twenty minutes to half hour it is kind of a directionless mass. After a short while the mass starts to behave as an organic unity and takes a certain direction on its own, even though I am partly manipulating it. It starts to make sense. Even if the people don't understand what they are doing, they physically know how to behave and there's a certain tone appearing that makes them understand what is more or less correct to do. Therefore there is some combination of control and loss of control, which is not the same as improvisation. I often tell them that they are improvising because that's a word they can relate to, but I don't think it is really improvisation.

Mik operates in controlled happenstance both in his "direction" of crowds on-screen and with his viewers. His first cast members, such as those in *Fluff*, were friends of friends or relatives, enthusiastic amateurs with whom Mik had no direct

emotional connection but whom he trusted because of their relationship to someone close to him. As Mik's pieces have become more heavily populated, even epic in size, he draws from a wider group of extras, including some with professional performing experience. Whether to accentuate or explode the notion of authenticity, Mik began using extras whose real-life jobs or duties overlap with what they pretend to do in his films. In *Osmosis and Excess* (2005; p. 42), sequences of which take place in what appears to be a supersized drugstore, actual pharmacists were employed to be "actors" dressed in the same white smocks that they wear at their day jobs. Both the real and the pretend pharmacists stand by their dispensing counters, walk the aisles, and seem oblivious to the mud creeping into their establishment. Not only can the "authentic" pharmacists not be told apart from the "inauthentic" ones but it does not seem to matter. Or, on an existential level, does it? Does one casting strategy imply fiction and the other documentary? But if a difference cannot be discerned, is the question even necessary? This mix of the real and the fake is an extension of the artist's strategy of blending levels of reality that may be traced at least to Mik's film *Middlemen* (2001; p. 34), in which one performer is not live at all, but a carefully crafted dummy.

Performance in a Mik piece comprises motion. It is through movement that social cohesiveness is obtained. The individual is anonymous; with few exceptions facial and body language remain restricted and flat. Other aspects (costume, skin tone) provide sufficient definition. Of his casts Mik has said:

> I am intrigued by the figure of the extra because the extra has a certain dignity. That suits me because they are happy to be on-screen and that's enough for them. They have a certain modesty about them that they don't want to put themselves so much in the foreground. They don't disturb the group too much by having too much presence, and yet they still relate to objects in space. They have presence but not too much.

Mik's notion of film is expansive and suggests another way of appreciating cinema outside the theater. He disdains the darkened room. He seeks an area lit at a constant level with either natural or artificial light. (The technology of digital projection allows this.) The viewer's glance is divided between what is moving on the screen and the human activity around Mik's sculpted walls, which are built tall enough to frame the life-size image and often short enough so that the viewer can easily see over them. Peripheral vision, including seeing the source of projection, is important. The projectors and the hardware containing the digital information are placed at floor level or hung from the ceiling. Nothing is hidden. Mik's installations demystify the experience of film while at the same time they affirm the power of the moving image.

Some of Mik's films are made to be shown on a single screen, others in specific multiscreen arrangements. The screens may be recessed into a temporary wall, stand perpendicular to the floor, or hang so that they appear to float, parallel to a wall, but the moving image will never simply be projected onto an existing surface. The works are interruptions in space, and a white gallery wall does not provide this possibility. Through architectural intervention and in creating a three-dimensional entity that holds two-dimensional images, Mik creates a "faux" depth that enriches the experience of viewing. In Rudolf Arnheim's 1933 thesis on film aesthetics, *Film as Art*, he noted, "It is a property of photography that it must represent solids 'one-sidedly' as plane pictures. This reduction of the three-dimensional to the two-dimensional is a necessity of which the artist makes a virtue."[4] By keeping the entire depth of field in clear and sharp focus within the frame of the moving image, Mik plumbs this virtue of reduction while at the same time restoring a third dimension to photographic representation

through an architectural framing. Mik's works suggest an ontological riff on perception.

In none of Mik's multiscreen works are the screens contiguous. There is always a distance between the images playing on the individual screens. The images that appear simultaneously on different screens relate to but are not extensions of each other. They do not cohere into a unified panorama. This separation not only reinforces a sense of space but also helps deconstruct the notion of the moving-image frame. The action within most of the frames is described in shots that move. In other words, because the moving-image frame tracks or pans along with the camera, there is no apparent limit to the frame and often the artist provides no way of orienting a viewer to the perimeters of the landscape in which the activity unfolds. A series of moving images often takes place in a discrete boundaryless field that cannot be comprehended in its entirety. Nevertheless the viewer cannot help but want to understand the space, and thereby somehow "control" it: this will is inherent to intelligence. In a two-screen work like *Training Ground* (2006; p. 72), which takes place in a tight outdoor area where guards with weapons oversee/harass/abuse/corral/search detainees against a background of parked police vehicles and transport trucks, it would seem that a coherent plan of the set could be conceived with a little effort by the viewer. Not so. The field of activity stretches beyond the frame of the moving image: its perimeters, which the viewer assumes are limited, are not at all evident. By shifting sequences shot in different parts of the field from screen to screen, Mik deprives the viewer of contiguity and presents a puzzle that, like the violent action described in the work, cannot be solved. Both space and meaning are elusive.

Vacuum Room (2005; p. 50), on the other hand, does describe actions in a defined space, an official chamber, and is required to be viewed within a defined space as well. Its six screens are set into six walls, slightly separated from each other,

that provide a discontinuous and uneven circumference of a room. This sculpted room needs a room of its own in which to be installed, making it suitable for a gallery. Unlike many of his other films, for this work Mik used fixed cameras that do not track but do tilt on their axes, leading to the sense that the goings-on in this government room, a space filled with the trappings of authority—chandeliers, carpets, statues, and, of course, flags—were caught on surveillance cameras. During a boisterous debate (complete with shoe-banging) a protest group bursts into the already contentious assembly, exacerbating tensions and creating a power vacuum in which order is threatened and authority compromised.

Viewers are invited into the room created by the six screen-walls to sit and observe the action in this legislative (?) or judicial (?) chamber. Once again the tendency is to try to understand the topography of the space, and given that this area is surveyed in its entirety (maybe) by six cameras, the viewer assumes this task must not be difficult. Mik subverts this process by scrambling the images so that scenes recorded by, say, camera number five do not always appear on screen number five but at various times on screen number two or number four. In spite of the work's specificity—a brouhaha in an official room—much remains unclear. There is no chronology. The piece does not open with pictures of the ministers in session. In fact it does not open it all. The way Mik positions his telling precludes any beginning, and without a beginning there can be no middle or end. The work "starts" whenever the viewer first encounters it, and then continues and loops and continues some more.

This meandering of time and space is as true of *Vacuum Room* as it is of the single-screen work *Scapegoats* (2006; p. 62), set in a roofed stadium and its immediate exterior, where a disparate group is held prisoner (?) or hostage (?) by another group also lacking homogeneity. Some members of this latter group have military uniforms, some weapons, some neither, some both. During the course of *Scapegoats* the group that is

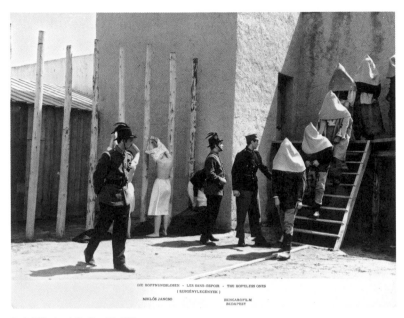

Fig. 2. Miklós Jancsó. *The Round-Up*. 1966

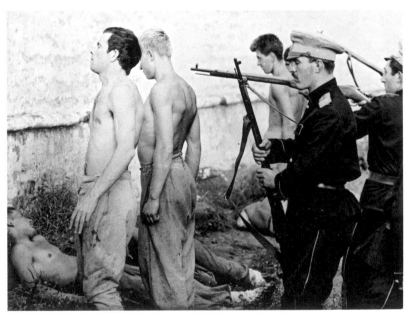

Fig. 3. Miklós Jancsó. *The Red and the White*. 1967

apparently in charge obliges the other to move outside. Incidents transpire, some brutal. But what exactly is going on here? The answer is not clear.

What does seem to be at work in Mik's creations is the recognition of collective memory. The artist operates with the assumption that the viewer carries with him information filtered through the mass media. The viewer approaches a Mik piece with general notions of the world he has witnessed in myriad mediated ways. Seeing *Scapegoats*, the informed viewer cannot help but think about New Orleans in the aftermath of Hurricane Katrina, or in the case of *Training Ground* or *Vacuum Room* about the flow of illegal immigrants into Western Europe or questionable parliamentary procedures in former Soviet republics, respectively. Consciousness of and a presumed concern about recent history, shared by the public and artist alike, are only the starting point, the seedbed in which Mik plants his images.

Mik's moving images are resolutely non-narrative. They are an accumulation of like moments that defy climax. There is a unity to what is shown but this unity owes more to Lewis Carroll than to Aristotle. In speaking to Hester Westley, the artist described what happens in his films as "patterns of eternally different variations. So although there is action going on, there's also a sense of stretching time. You can spend time with my work and try to reposition yourself in relation to the imagery."[5] In this repositioning, the viewer brings his own personal experience and social memory into play, thus investing the images with the signification the artist withholds: what happens on-screen is not explicated but can begin to be understood, incompletely, through what the viewer knows of recent history.

All of Mik's films are looped, and it makes no difference what scenes are playing when a viewer first encounters them. The loops tend to be lengthy, each over half an hour, and there is no sign or signal to indicate a repeat. Within a loop no scene is replayed, though Mik does include sequences that are close approximations of one another. However, no matter in what order they are encountered, the sum of these accumulations will not make sense except in a vague way. The longer a viewer watches, in fact, the more uncertain he becomes. This uncertainty has a curiously mesmerizing effect. Time is both stretched and conflated.

Many contemporary artists refer to or even appropriate from the collective memory of popular movies; Mik does not. Without any formal film training in either the making of movies or in the history of cinema, and lacking any particular enthusiasm for this medium, Mik does not allude to or invoke other filmmakers. To this viewer, however, his films evoke those of master Hungarian filmmaker Miklós Jancsó, whose works were unfamiliar to Mik.[6] Jancsó's works are pared to the point of abstraction and may be seen as situations rather than narratives with plots. Jancsó's notable shooting style involves long, complex, and graceful tracking shots in which groups assemble, disperse, and—because the camera moves at times with more speed and deliberation than the "characters"—disappear out of the frame. In *The Round-Up* (*Szegénylegények*) (fig. 2) government forces arrest citizen rebels who then turn on themselves. *The Red and the White* (*Csillagosok, katonák*) (fig. 3) opposes two groups of soldiers who trade victories and humiliations, crossing and recrossing lines of victim and victimizer. Without being aware of Jancsó, Mik shares not only signature elements of style but also an understanding of the syndrome in which those who are oppressed will sometimes identify with and replicate the behavior of their oppressors. This phenomenon accounts in part for the intermingling of groups described in many of his works.

While Mik's films may not stand apart from the constructions he builds for them, they are remarkable for their clear cinematic qualities—how they move, how they are framed, and how they are edited. The artist, unschooled as a filmmaker, appears to have an intuitive grasp of how to make this medium of movies resonant without the aid of narrative and individual

performance. His films suggest situations that remain unresolved, and in witnessing this irresolution, the viewer experiences not only a tension and anxiety but, in anticipating what may happen next, suspense.

In their presentation and spirit, Mik's films are original even though his mode of production is traditional. During the preproduction period, money is raised and a crew assembled, including key collaborators: the art director/set designer who, once Mik conceives the field of action, finds and details the location; the director of photography; and the assistant director, who as the wrangler of groups on set is more like a codirector. In addition to this team, with whom Mik tends to work from project to project, a costume designer is hired, as is a casting director to find the "extras" for his ensembles.

It is on the set that Mik decides how his cast will move and what incidents he will cause to transpire. With his cameraman or cameramen, he discusses the rhythm and the framing of what is to be shot, and gives them liberty to achieve the desired effect. Mik's cameras glide on a horizontal track or on a vertical crane; they may pan on their axes but they are seldom handheld. The shooting is done without rehearsal. Since there is no soundtrack to record, the filmmaker is able to give directions during the shoot. Mik has described the process of filming:

> Part of my strategy is to work with extremely long takes because it brings people into a mood wherein they can forget what they are doing. Time takes on a presence of its own. I even put rest moments in the scene. Length of time of shooting is very important because it gives a sense of continuity, but not in the conventional sense. I shoot a couple of hours of material every day and usually after two days I have five or six hours of material from which to work.

Mik has generally worked with the same team since he began making films. Like Rainer Werner Fassbinder, who repeatedly worked with the same set of collaborators so that he could shoot quickly and carefully without much explanation or instruction, Mik conveys his ideas in a few short sentences to his crew. Not only are these collaborators familiar with the artist's vision and technique but they also share a mutual trust. In the world of commercial moviemaking, the names of set designers and cameramen, among others, are inscribed on the films on which they work; in the arena of art-making, they, like studio assistants, tend to remain anonymous, as is the case here. With Mik there are at least two strong formal reasons to maintain this anonymity. The first and most obvious is that there are no beginnings or endings to the works, and so there is no point at which to make these acknowledgments. The second is that, although these works are fiction, they appear to be documentaries, unfabricated realities filmed by the artist. That we know this is not the case does little to mitigate our feeling that it is.

Mik edits his films digitally by himself in his Amsterdam studio. He cuts them not for spatial and temporal clarity but to relate one "accumulation of moments" (usually in an extended single shot) to another in a way that carries an emotional punch without providing narrative continuity. What distinguishes Mik's cutting and provides a sense of unease in the viewer is the total lack of reaction shots—a separate shot, often a reverse of the prior image, to a reaction of the previous action—the building blocks of narrative cinema. Action happens. There is no response. Another disorienting factor is that Mik cuts his films in such a way as to suggest that there is no out-of-frame action, implying that all that there is to be perceived is to be found within the image. Mik uses jump cuts to abbreviate time. He edits sequences for simultaneous multiscreen projection that are not themselves simultaneous. This keeps the viewer busy glancing or moving from one screen to the next trying to determine the relationship of one image to another. Whether single-screen or multiscreen, Mik's editing provides a visual

rhythmic coherence that has its own disjunctive yet spellbinding aspect. Contemplation of a Mik work is anything but meditative.

The end of editing a film traditionally signals its completion. "Locking" the film, however, is only part of the process of making a Mik piece, because the artist views the film as just one element of the work. The film has to be exhibited, and the construction in which it is shown, whether a wall in which a screen is set or a particular surface volume to be hung or floated, has to be built. Although a film may be shown in many different spaces, the structure that contains the film is specific to its location and is modified for a particular site depending on factors such as light levels and foot traffic. The placement of projectors is decided in concert with another set of trusted collaborators, a team of media installers that determines equipment requirements, archives materials, and reformats the digital information when necessary.

Mik's films are silent, but the absence of sound is not conspicuous. His movies speak through the mind of the viewer as well as the ambient sounds of fellow viewers. In cinema, sound tends to reinforce the literalness of the image, often making it mundane and constricting the imagination of the spectator. Hearing conversations, orders being barked, pleas being made in whatever language adds a mimetic dimension the artist shuns. Language specifies location and renders regional or provincial what may be universal. Images are understood worldwide, not so words. An image without sound is more concentrated, denser, richer in allusion than one made safe and mellow by dialogue, whether scripted or natural. Sound would alter the relationship of the viewer to the screens from which the sound emerged. Sound would be reductive.

One notable exception is *Raw Footage* (2006; p. 54). This powerful double-screen work is distinct for two reasons: it is composed entirely of found footage—that is, actual newsreel footage—shot in the 1990s during the civil wars in the former Yugoslavia, and it includes the sounds recorded as the footage was shot. According to Mik, *Raw Footage* grew out of "things I am researching and trying to develop in my 'fictional' work thinking about social and personal uncertainty in a civil war... about a kind of personal 'trembling' in areas of crisis." Certain that there was less sensational footage of the Balkans than what was seen in the eye-catching newsreels broadcast nightly, Mik, in search of images of ordinary people in extraordinary times, traveled to ITN Source in London, one of the world's largest newsreel libraries. There he found so much material about the former Yugoslavia that a few boxes of tapes in the basement had never even been examined. Footage from these boxes, as well as other material that he found in Belgrade, Sarajevo, and Zagreb, are the discards Mik uses in this work.

Projected on two noncontiguous screens hanging side by side, *Raw Footage* presents people—soldiers and civilians—going about their business during a war. Even though Mik's selections appear to be "raw," unedited and uncut, as if they came direct from the newsreel camera, there is a pervasive sense of unreality about the images. In their own understated way, these resurfaced materials are even more devastating and absurd than any fabrication. Soldiers fire arms, militia women put on makeup, cheery children carry rifles, buildings smoke, animals sniff and wander through rubble, detainees line up, young people sit in cafés, and corpses are sighted. Truth is stranger than fiction. At times during the projection one screen or the other goes black, and at other times both screens darken. When asked about this presentation strategy, Mik replied:

> Going black creates kind of chapters without really leading to an end. The gap creates an expectation of something else about to happen all the time. The little chapters do two different things. First, they articulate one kind of situation, and sometimes they morph, they transform themselves within one episode from one situation to another. And

then, of course, the double screen sometimes is used for creating sudden relationships, unexpected relationships between different views....It is a different way of reading this material that you could not have had on a single screen presentation.

Mik avoids showing the act of dying, but he does show soldiers shooting and a few dead. Without narration, a man in rigor mortis is pulled from a river, another is felled by a wall; the bodies of civilians, murdered by sniper fire, are hauled off the street and thrown onto flatbed trucks. Without narration and with the muted ambient sounds of gunshots, barking dogs, explosions, and conversations, these images seem so flat and uninflected that the viewer, deprived of drama and sensational-ism, remains detached but fascinated. With the civil war in the Balkans over, the images may have lost their immediacy but not their powerful signification: where killing is commonplace, people adjust and an eerie normalcy emerges. Despite its cool surface, *Raw Footage* is an angry, perhaps despairing work.

The trajectory from the chamber piece that is *Fluff* to the broad outside world of *Raw Footage* is one of increasing engagement. Mik himself acknowledges this transition: "I began on a domestic level, with small groups of friends of family.... I started with more private situations and am moving to more public ones, to the physical dramas that are taking place with groups in the public sphere. From the moment you enter that sphere it is hard to avoid the social-political dimension. It just comes in stronger and stronger."

This "stronger" dimension is a reaction to the profound changes in many Western nations where issues of second-generation racial and religious assimilation, immigration, and terrorism are altering social coordinates, and in particular in The Netherlands, which has experienced its own ongoing debates about citizenship fueled in part by devastating assassinations. This sense of engagement with the world was reflected in the title Mik gave his exhibition that occupied the Dutch Pavilion at the 2007 Venice Biennale, "Citizens and

Subjects: The Netherlands, for Example," at which *Training Ground* premiered. In speaking with Maria Hlavajova, who organized this exhibition, the artist, usually guarded about his personal life, said:

On a private level—and I am aware this might sound exaggerated, but I feel very strongly about it—this also has to do with becoming a father. This radically changed my perspective on the world. Everything becomes less about yourself and much more about others, to put it simply. I discovered a different urge to take responsibility for certain things in the world.[7]

In this regard Mik's work recalls what Siegfried Kracauer wrote in reference to two major mid-twentieth-century artists, Roberto Rossellini and Luis Buñuel:

The point is, rather, that the cinema does not simply imitate and continue the ancient gladiator fights and Grand Guignol but adds something new and momentous: it insists on rendering visible what is commonly drowned in inner agitation....In deliberately detailing feats of sadism in their films, Rossellini and Buñuel force the spectator to take in appalling sights and at the same time impress them on him as real-life events recorded by the imperturbable camera....The cinema aims at transforming the agitated witness into a conscious observer. Nothing could be more legitimate than its lack of inhibitions in picturing spectacles that upset the mind.[8]

In his art, Mik moves this upset a step forward by applying it not only to his powerful and strangely beautiful images, but to the way in which they are, in company, perceived. He keeps us awake, thinking.

Notes

1. Jaap Guldemond, *NL: Contemporary Art from the Netherlands* (Eindhoven, The Netherlands: Stedelijk Van Abbemuseum, 1998), p. 78.

2. Unless otherwise indicated, all quotations by Mik were extracted from a series of interviews the author conducted with the artist in his Amsterdam studio in February 2007.

3. Subsequent to *Fluff* Mik shot all his moving images not on film but electronically and with digital technology. From the appearance of the first videos in the 1960s artists have used the term "film" to connote work with duration and in-frame movement without regard to the medium in which the work was photographed. This essay uses "film" as it is now commonly understood as a "movie" and not as an analogue process.

4. Rudolf Arnheim, *Film as Art* (Berkeley and Los Angeles: University of California Press, 1957/1969), p. 44.

5. Mik, quoted in Hester R. Westley, "Crossroads: Aernout Mik Interviewed by Hester R. Westley," *Art Monthly*, no. 305 (April 2007): 2.

6. In the same interview with Westley, Mik said, "In a similar manner to filmmakers liked Gus Van Sant, I am creating an area that is an accumulation of moments—they don't make a narrative but it is a crossroads." Ibid., p. 3. This is a rare but telling reference by Mik to a filmmaker. Van Sant has frequently cited Béla Tarr as a major influence on his cinema, and Tarr, a Hungarian filmmaker a generation and a half younger than Miklós Jancsó, was in turn influenced by his older and critically celebrated countryman.

7. Mik, quoted in Maria Hlavajova, "Of Training, Imitation, and Fiction: A Conversation with Aernout Mik," in Hlavajova, Rosi Bradiotti, and Charles Esche, eds., *Citizens and Subjects: The Netherlands, for Example. A Critical Reader* (Utrecht: BAK, basis voor actuele kunst, 2007), p. 42.

8. Siegfried Kracauer, *Theory of Film: The Redemption of Physical Reality* (New York: Galaxy Book, 1965), p. 58.

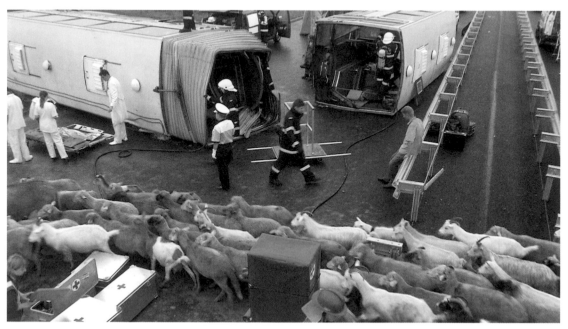

Fig. 1. Aernout Mik. *Refraction*. 2004. Single-channel video installation (color, silent), looped

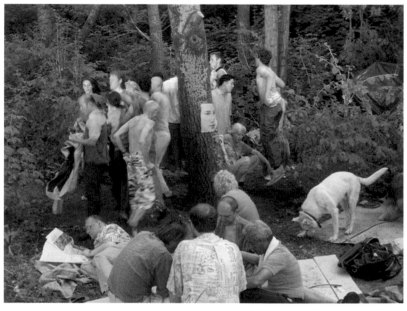

Fig. 2. Aernout Mik. *Park*. 2002. Single-channel video installation (color, silent), looped

MICHAEL TAUSSIG

AERNOUT MIK: LOOPING THE LOOP

You are on a train moving like an arrow from Berlin east into Poland. Dawn is breaking. Everything is saturated with cruel history: invasions, bloodshed, shifting borders, "regime change" (do they really change?), work camps known as death. The humble gray houses by the side of the well-kept fields don't give away much. The train rumbles on. You grip the railing in the corridor and keep looking at the silent landscape, trying to get a message or a meaning from what you see. You might glimpse a woman come out of a house and water flowers. There a man walks with a dog. What about those tall chimneys? The woods look so pretty. As the sun floods the land with light you shake your head. It can seem as if you are still and it is the landscape, not you, that is moving. Why, it's like looking at a movie by Aernout Mik!

It is a cliché that photography and film change the way we see reality. It is a cliché because nobody believes it, and therefore it must be continuously repeated. And when you say the same thing over and over again it becomes clichéd. Such is the impact of Mik's videos, silently, blandly holding the camera to the world. No shuddering montage here, leaping from scene to scene. No tricky camera antics. Even when crazy stuff is on the screen—a bus turned over on the highway surrounded by sheep (fig. 1), teenagers with guns prodding pathetic old men in the Balkans, ordinary folk jumping up and down around

a tree for no reason (fig. 2)—it seems like nothing much is happening. A strange calm settles over what we are seeing. The repetition is dulling. There is very little to it, or so it would seem; even the bizarre becomes ordinary.

Is what we're seeing, then, the world in its everyday-ness as depicted in James Joyce's *Ulysses*, with a camera replacing language? For the absence of language, like the silence, is palpable (another cliché), and that's probably the main reason you might ask while watching these films, Is that us? Is that the world? The silence impugns reality. The props and cues we rely on for interpreting reality peel away. We have to live with doubt. "That's art," we might say with a shrug.

Truthfully, most of us don't spend much time contemplating the world shorn of sound. We ache for a voice to tell us how to see. The days of silent cinema are long past, so what's going on with these Mik-movies—which, while moving, seem never to be going anywhere? Not only is there no narration, there's no narrative, no beginning, no middle, and no end. More like a loop.

Most people love film because unlike drawing and painting it seems so real. Yet it is a given that the images are highly contrived in order to achieve a specific effect. The filmmaker chooses to either exploit this reality-effect or instead use it to show us showing. That is why, despite their onerous calm, Mik's movies should remind us that filmmaking is a desperate art, an art that hovers between changing the way we see reality and reinforcing the norms of visual culture. Mik does both.

While it's true that there's no speech in these films, I should now add that it seems to me they have a silent partner in dialogue: the thunderous, everyday voice of Fox News and its congeners such as CNN, brought to you by the latest SUV and shampoo carrying you cleansed and ever more beautiful into consumer culture. Mik's films do not engage with Fox and others at the level of ideology—for example, the terror of the War against Terror. Yet that is a little misleading. Rather, these films

engage with the ideological campaign waged by Fox because this ideology is first and foremost expressed in ways of showing/ways of seeing. In other words, in the films you see the means of artistic production and become an interpreter of imagery, not merely a recipient.

Would that the field of engagement were neutral! That the eyes and brain were neutral so all the filmmaker has to do is show us something in a different style so that we will snap into another mode of seeing and hence, if all goes well, snap into another mode of understanding. But what if the eyes and brain have been "fixed," so to speak, by Fox and its ilk? What if little by little we have been brainwashed since the advent of cable news and the rise of twenty-four-hour commentary into specific ways of understanding not just film and film culture but more pointedly TV news, from Fox to CNN's Wolf (Blitzer)? In that case, Mik and others, working with what's available, use this newly implanted Fox eye of ours to un-Fox it. How you outfox a fox or a wolf is no easy matter. But presumably a lot of fun.

One important trick is no sound. The silence can be irritating, even worrying. There is no "natural sound" of people talking in the background, car brakes squealing, cows mooing, footsteps echoing, wind sighing. The train keeps moving east. All you seem to hear is the rattle of the train. It could be the rattling in your head. And nothing could be more alienating than this silence because the material presented so desperately calls for sound of some kind. This is no artsy Stan Brakhage impressionist art film where you swim with changing colors. We know how to relate to that, an inspired exploration of color and form. With Mik-movies the strangeness comes from the familiar being so estranged.

I recall a seminar I attended in graduate school where my teacher, Keith Hopkins, said nothing for the entire two-hour class. Who should talk, and how, and about what, and why were we there—all of the rules collapsed. There was a corrosive eating away at the fabric of normality. Mik's movies do the same to the normality of media. Despite the silence in these works, I believe you eventually do hear something, and that is the muted echo of what is missing—what should be there but isn't. That is the voice of the news anchor—sassy, know-all, wide-eyed innocent—who come in several shapes and sizes like the SUVs and shampoos that pay them.

SUVs and shampoos are in fact the subject of a major motion picture brought to you by Mik Films as a fine example of magic realism, in which one product metamorphoses into another via death and animal husbandry. The shampoos in question, in the film *Osmosis and Excess* (2005; p. 42), are actually but a part of a vast display of boxes and bottles packed more or less orderly, one on top of the other, in what looks like the storage room of a large pharmacy. This scene is carefully examined by the camera, box by little box, snail's pace slow. A man is foregrounded sorting through them. Man at work. Perhaps a pharmacist. An incongruous note is struck by a man of color digging mud out of the center of the room, his uncouth presence and that of the mud suggesting "raw reality," while the heaped boxes, by contrast, imply the commoditized world most of us inhabit.

This ever-so-slow, arthritic camera eventually veers away and takes a walk into the country, seeking out more of that "raw reality." We are up high now, flying hundreds of feet in the air. It's nice and green below, with cute white houses in clusters on the hills. No sound. Of course. All is still up here in the hills. But wait a minute (we've done plenty of that, right?), those cute little houses—are they not carcasses spread out on the hillsides, carcasses of cars, a mountainside junkyard? The camera picks its way delicately among the dead like the pharmacist among his goods. Some children appear and beat up on a piñata hanging just within reach of their clubs so that, when injured enough, things spill from its innards. There they go, whacking away, desire on tiptoe reaching to the sky. In the meantime those cute villages of car carcasses scattered across the hills have changed

into sheep roaming and munching aimlessly o'er hill and dale. And so we ever so slowly return to the pharmacy to watch over the little boxes and bottles.

As I said, a loop, an eternal return to Karl Marx's strange notion of the fetishizing of commodities, which makes material things come across as spirits. Then there is the even stranger notion that fashion—as with shampoo and SUVs—is the death ritual of commodities. No sooner are fashions born than they die to make way for the next product, such that little boxes transform into dead cars that take over green mountains that make us sick so that we need more pills. A loop. A magically real loop, but don't expect the sentimentality of the Isabel Allende type of magic realism.

As for those spirits, they seem to inhabit other Mik films as well. All that milling around, like the sheep around the overturned bus in *Refraction* or the ragtag army of *Raw Footage* (2006; p. 54) that plays with its prisoners—they seem adrift, aimless, and not quite of this world. The men and women in *Middlemen* (2001; p. 34) who stand up, sit down, stand up again, walk in circles, reach for a phone there in the stock exchange, are they not possessed? They stare fixedly at something we cannot see. They are visionaries. Perhaps they are watching the playing out of the world as prices move up and down and up again. I guess. One man has a nervous tic and gestures spasmodically, like the West Africans possessed by the spirits of dead colonial officers in the Hauka cult famously filmed by Jean Rouch, the "father" of ethnographic film, in Ghana in 1955 (fig. 3).

Mik films gesture to Rouch's work in other ways as well, and it is this playacting by persons possessed that accounts for the disembodied look of his actors, as if they are taken over by something and have become blind instruments of fate who do not know they are such. For as we may later discern, *actors they are*. This certainly provides a jarring note. For is this not documentary? Now we learn they are fake—fake-real, that is—and our thoughts stumble.

Lost in thought we turn to *Raw Footage*, a recent work consisting of film scraps showing the conflict and ethnic cleansing in the Balkans that didn't make it into the evening news. War turns out to be slow and stupid, like the kids on tiptoe lunging at the piñata up there on the hill by the dead cars that were villages but then became sheep. The camera skids and—unbelievably—we hear something: dogs barking (dogs of war?), machine guns popping erratically, and, there in the background, very weak like the pulse of a dying person, waxing and waning, is the hum of human voices. It could be the person filming, but it seems more like a spirit, perhaps one of those Hauka spirits as captured by Rouch, whose hosts asked him to film them possessed so they could show the footage to future members of their cult.

Is Mik creating a cult for us too? Perhaps, but not the cult of the fox and the wolf. For what the Hauka teach is that through imitation you can also harness the power of what you mimic in order to overcome. This is how I like to think of Mik's movies. In imitating the fox and the wolf they give us the power to break free.

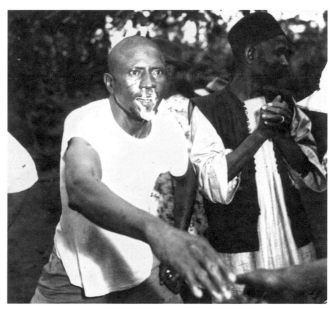

Fig. 3. Jean Rouch. *Les Maîtres fous.* 1955

Fluff 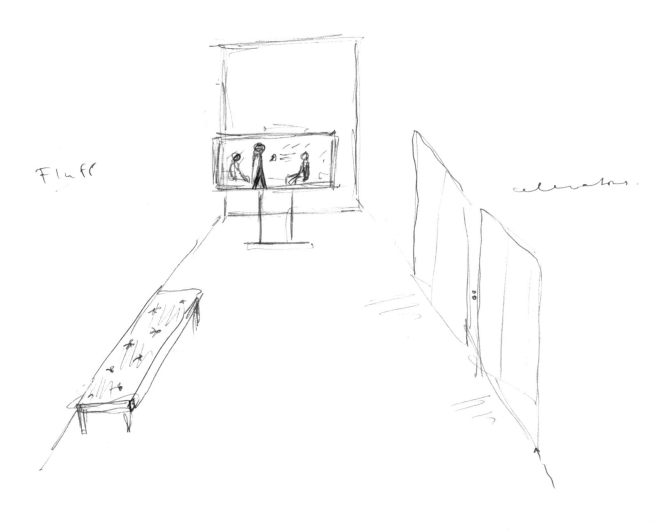 celebrators.

FLUFF

1996
Single-channel video installation (color, silent), looped
Courtesy carlier | gebauer, Berlin

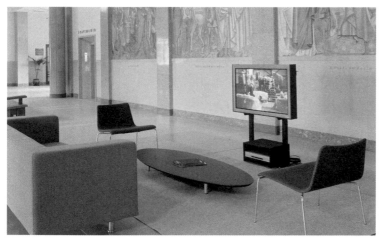

Installation view at the Porto Court of Justice, organized by Fundação de Serralves, Porto, 2001

Shot in super 16mm and digitally transferred, *Fluff* proceeds in a series of stationary shots. A small cast meanders through what appears to be a warehouse filled with plastic-wrapped furniture and shipping pallets. Men and women of various ages enter the fixed frame and walk, sit, stand, and pause before they wander out of view. An old man sits lamely on the sofa with his naked chest on display. In contrast, a young man with shaggy blond hair is the picture of health. Some of the figures slowly take off their pants or shirts with deliberate precision. At times one of the protagonists wears a mask that is very similar to his face, while a nearly identical mannequin's head rests on a table. As this head stares at the viewer with sustained intensity, the actors' movements and gestures continue. Although there is no conversation, the cast occasionally interacts on a physical level by posing next to one another. All the while pancake-sized wads of sticky material fly into view and land on their bodies, though this onslaught never elicits any reaction.
—*Kelly Sidley*

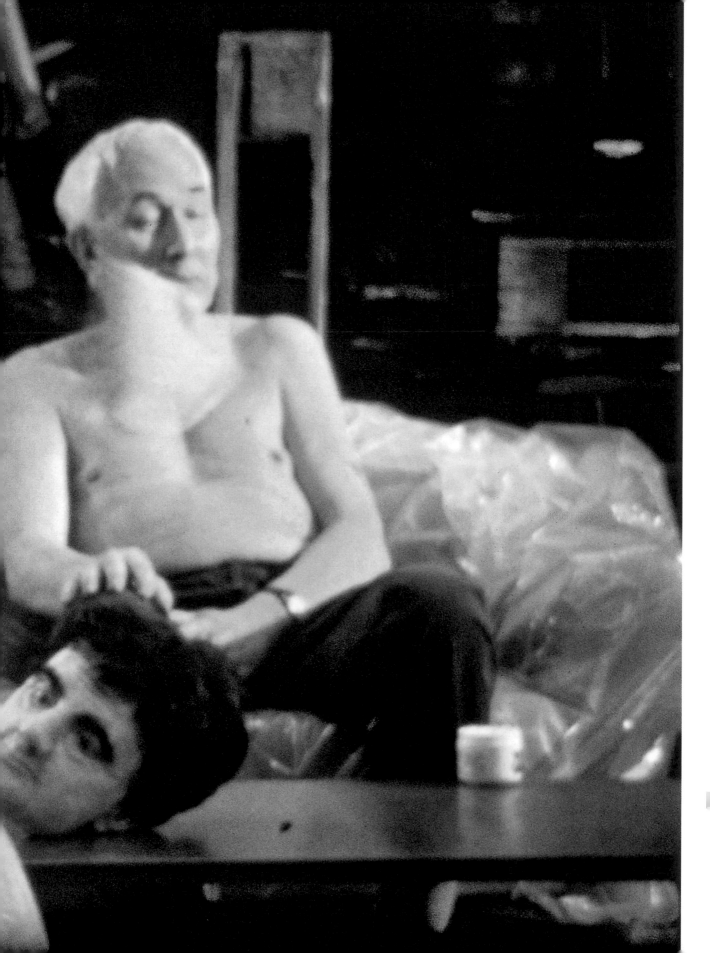

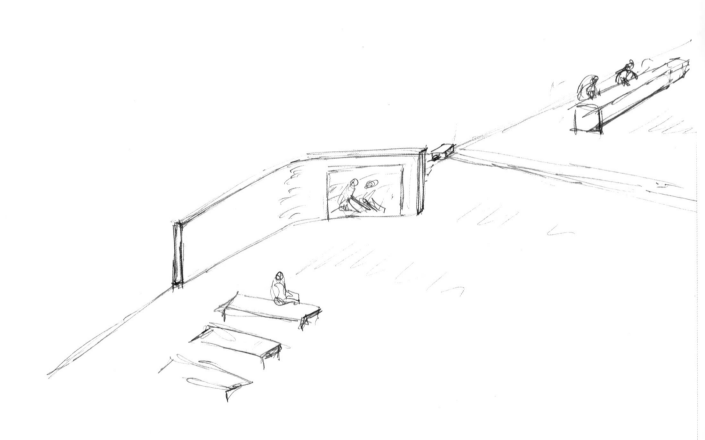

MIDDLEMEN

2001
Single-channel video installation (color, silent), looped
Rear-projection screen embedded in temporary architecture
Courtesy carlier | gebauer, Berlin

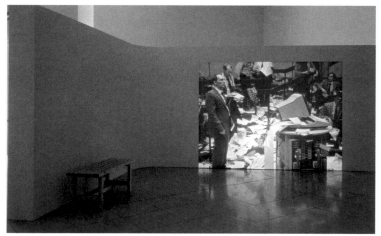

Installation view at Museum für Moderne Kunst, Frankfurt am Main, 2002.
Collection of Museum für Moderne Kunst, Frankfurt am Main

Middlemen presents a stock market floor or commodities exchange peopled with workers who appear to be nervously waiting for something. Traders occasionally scribble on pads of paper while porters collect the forms. Mobile communication stations with red-alert telephones and computers stand at the ready, but no information comes from them. Men and women, paying no attention to the papers littering the floor or the apprehensive expressions of their coworkers, pace back and forth or slump against the railings that define the amphitheater-shaped room. Each person seems to have been thrown into a permanent state of shock.

 The internal anxieties of these middlemen, whose haggard faces reveal the daily stress of their profession, find a physical outlet as their bodies twitch, jerk, and spasm. The camera's movements—long pans mixed with close-up details that jump to wider views of the room—mimic the spasmodic motions of the bodies and emphasize the jittery atmosphere. Mik continually returns to two figures who have nearly identical faces and are dressed in matching plaid jackets, which are also worn by others. As the pair gesticulates in not-quite-exact syncopation, their oddity contrasts with the very real unease of the crowd. Some traders discard their jackets, leaving them draped over railings or thrown on the floor before exiting the room. In the meantime, the stalwart continue to wait.
—*KS*

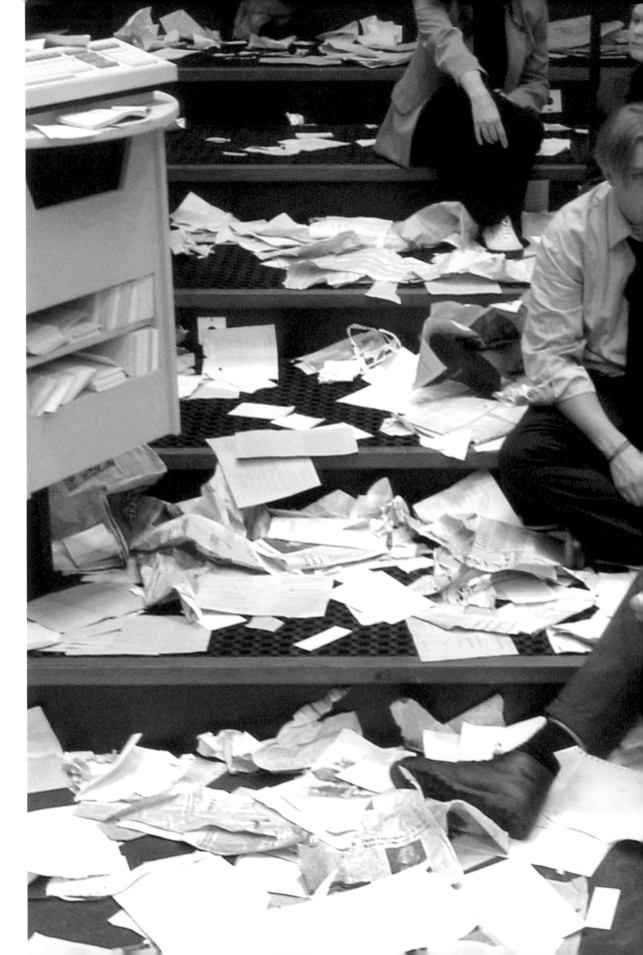

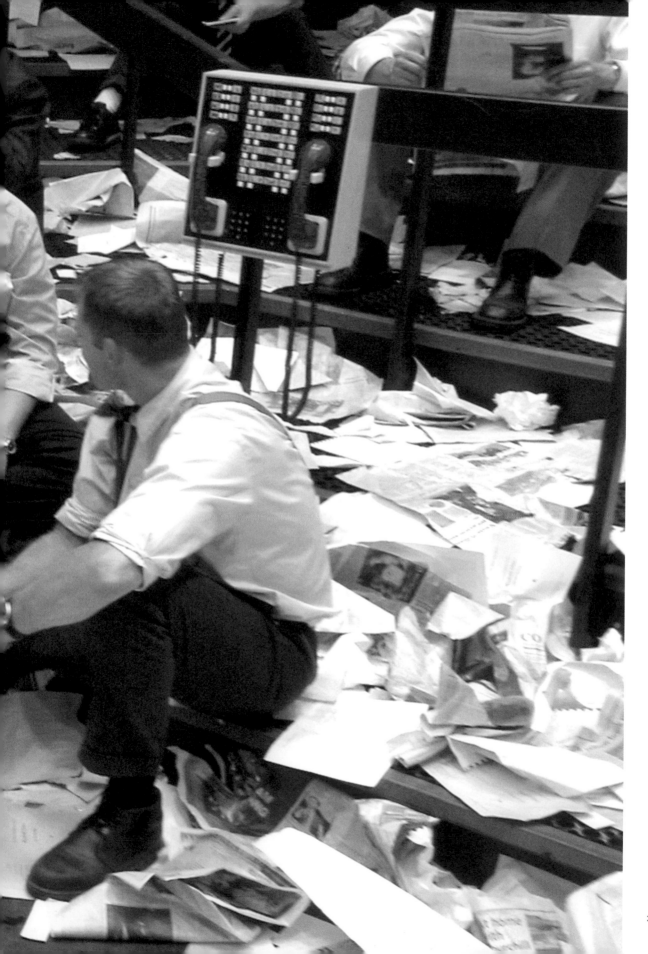

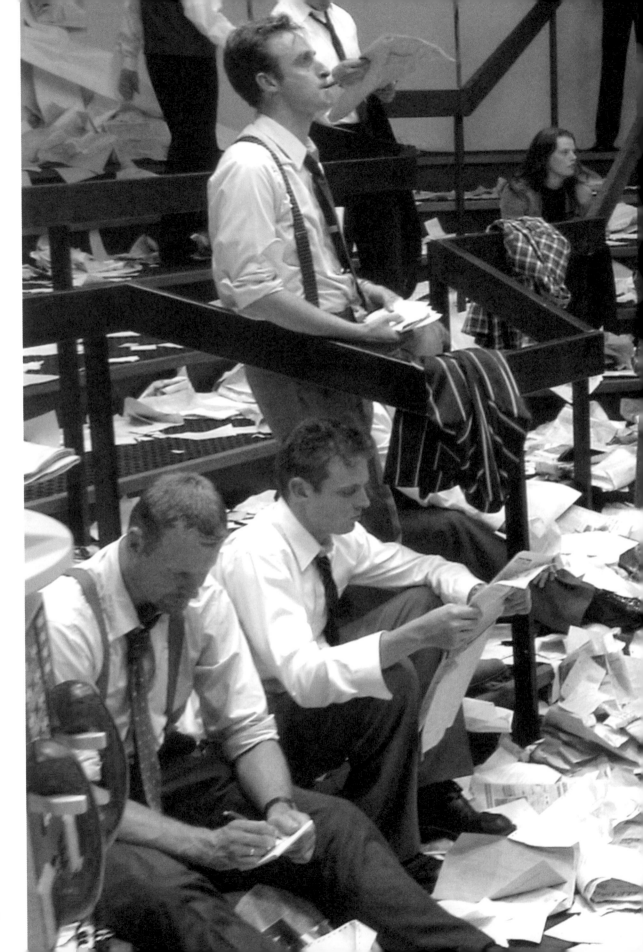

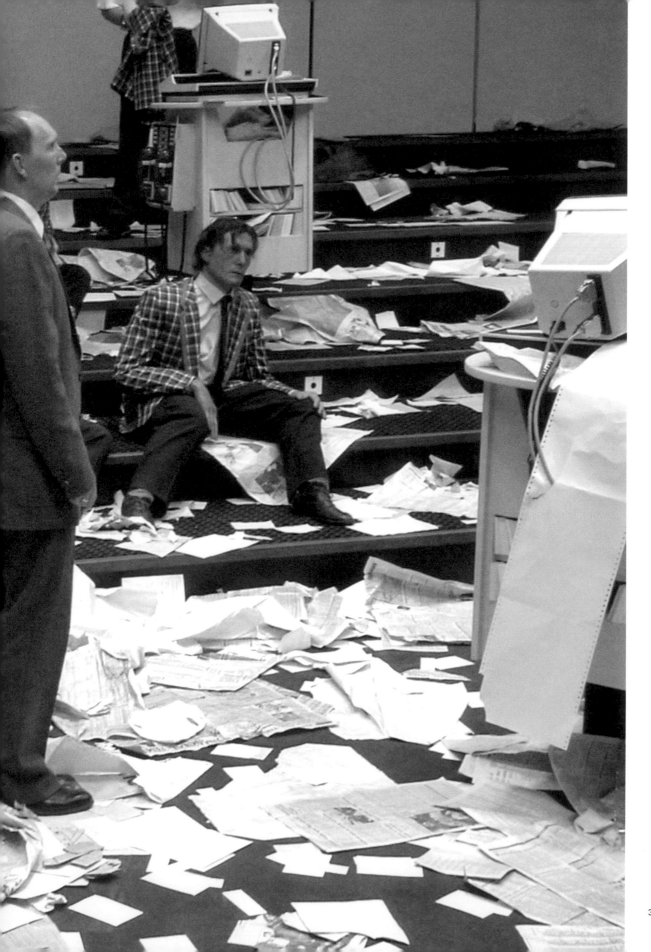

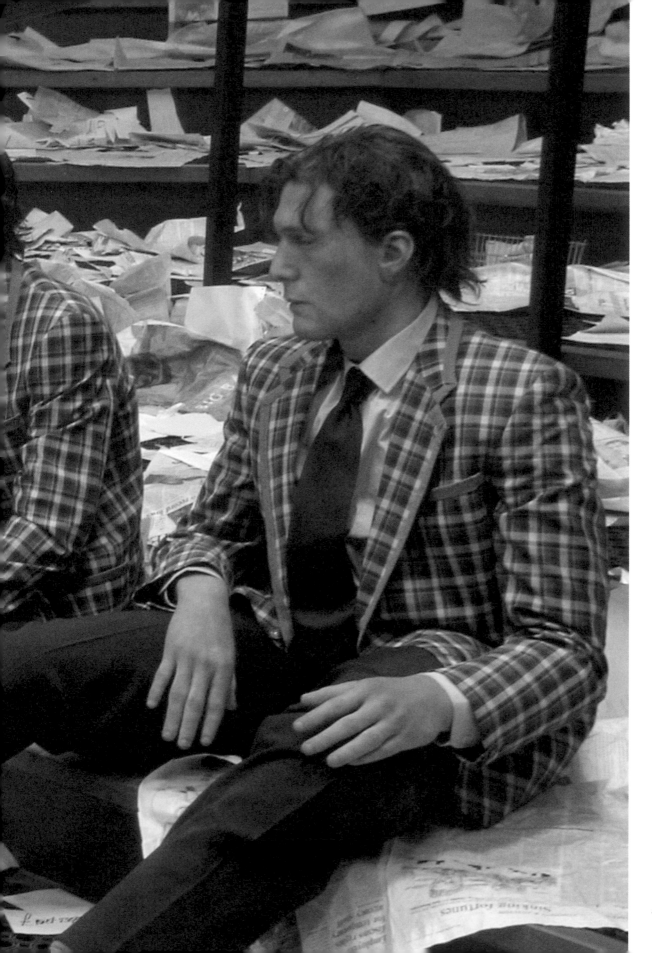

bookshop

osmosis

desk

lobby

osmosis.

OSMOSIS AND EXCESS

2005
Single-channel video installation (color, silent), looped
Courtesy carlier | gebauer, Berlin

Installation view at *inSite_05: Interventions and Scenarios*, San Diego, 2005

Osmosis and Excess opposes detailed views of two very different settings: an urban store in Tijuana, Mexico, and a car-strewn landscape just outside of the city. The first presents a pristine, brightly lit pharmacy peopled with workers wearing white coats. The merchandise seems to be orderly; colorful packages of medicine and other goods are stacked in neat piles and a banner advertises "save up to 30%." But as the camera pans through the store, it reveals ankle-deep piles of dirt. As mud oozes against the eye-catching displays, the pharmacy suddenly appears contaminated. Workers in overalls and waders dig in the muck while the pharmacists seem oblivious to the commotion around them. As the film shifts to the mountainous terrain near Tijuana, nature dominates the scenery, but only for an instant. In what appears to be a bucolic scene one slowly discerns thousands of abandoned vehicles tucked into the landscape, which has been turned into a junkyard for cars driven over the border from the United States. The hills also become a playground for youngsters who hit at piñatas and wait for candy to rain down. Amid the motionless cars and the boisterous children, cows and goats benignly graze on the grass.

While at first these two scenes appear to be opposites, similar imagery—prescription packages, pills, automobiles, sweets, toy cars, flocks of animals—appears in both places and forms a visual connection between them. By infiltrating both environments with the same elements, Mik links the two spaces and emphasizes the tangled relationships between consumers and the goods they ultimately discard.

—*KS*

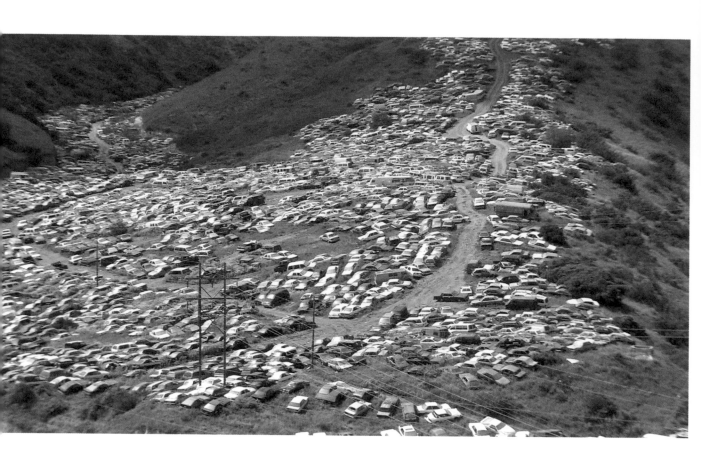

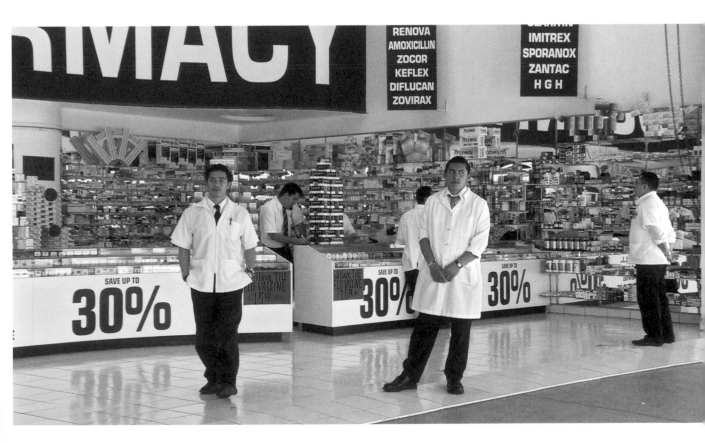

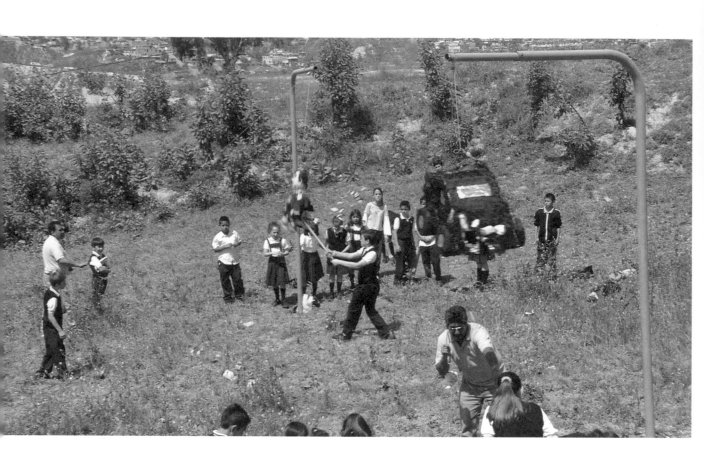

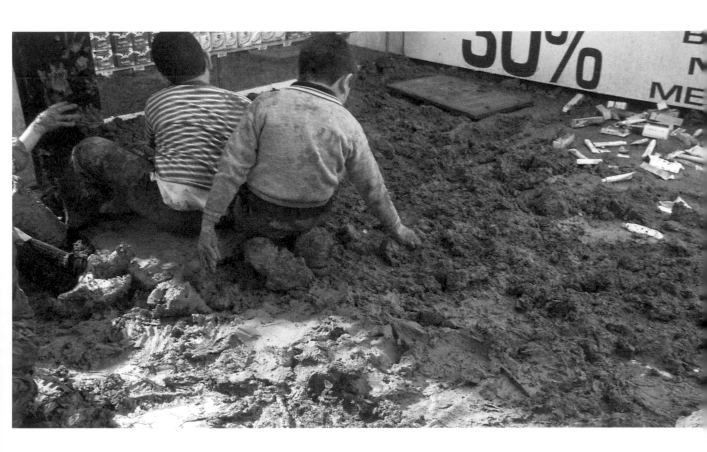

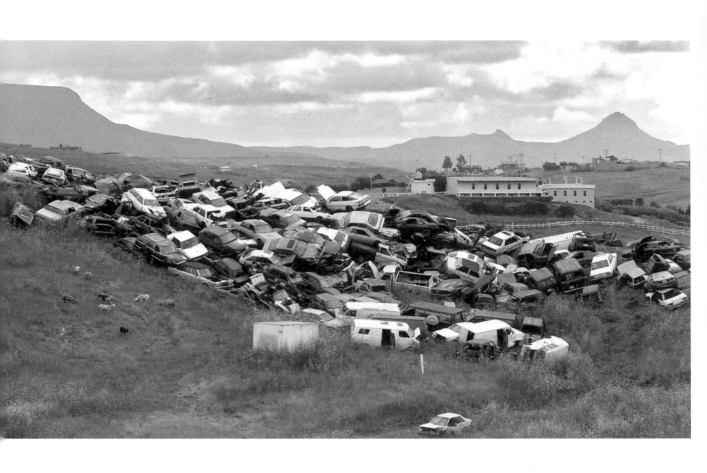

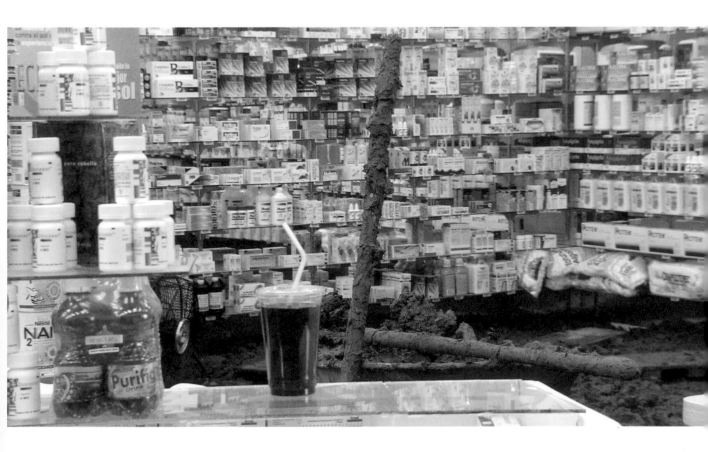

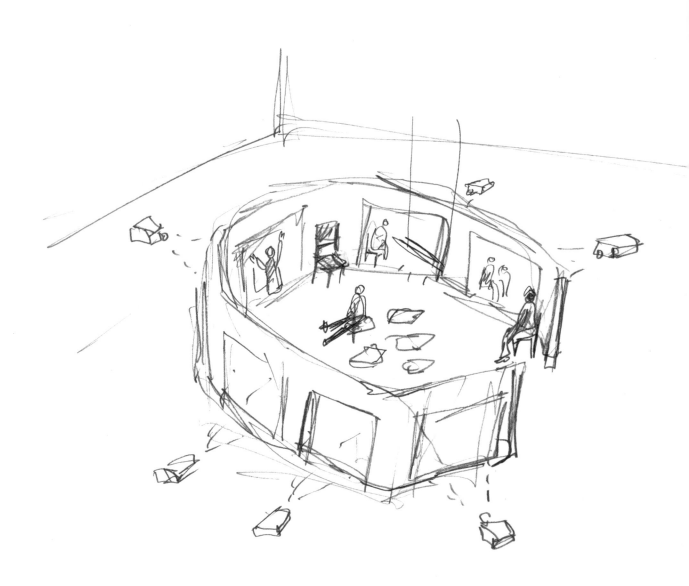

VACUUM ROOM

2005
Six-channel video installation (color, silent), looped
Six rear-projection screens embedded in temporary architecture
Courtesy carlier | gebauer, Berlin, and The Project, New York

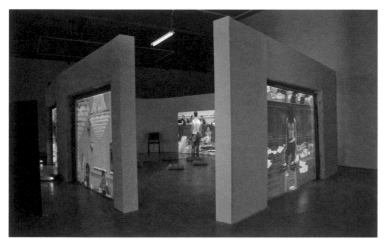

Installation view at MC Kunst, Los Angeles, 2005

A freestanding architectural structure, scattered with floor pillows and chairs, holds the screens for this six-channel video installation. The footage focuses on a band of rebels who enter what appears to be a legislative chamber, though the exact location never becomes clear. The work was filmed with stationary cameras, giving the scene an air of surveillance. Like all of Mik's work, *Vacuum Room* does not follow a linear sequence. As the viewer takes in the different screens it becomes apparent that the artist simultaneously depicts stillness and chaos, order and rebellion: one channel might feature an empty corner of the room while another is dense with agitated people. The absence of sound is conspicuous because of the confrontational nature of the scenario. While sporadic commotion is communicated visually by the protestors' antics, which include clapping, yelling, and banging their extremities on the floor, the viewer never actually hears the audio track of these actions.

Although the protagonists break down into two distinct groups, their conflicts are not waged solely against each other. A bearded man who appears to be the rebel leader defaces a bronze statue, presumably of a political or military figure, by smearing it with raw eggs. The politicians waffle between action and inaction, between disregarding the interlopers and shouting back at them. Tensions also emerge between the assembly people, who sometimes argue among themselves and ignore the protesters. Mik layers these various conflicts and allows them to unravel at the same time. Despite the hostile atmosphere, the situation remains peaceful. While both sides posture and perhaps even threaten violence, ultimately they only exchange words and gestures.

—*KS*

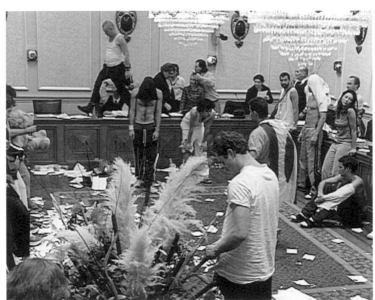

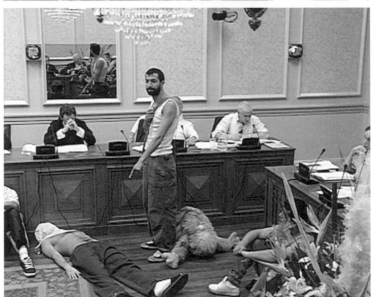

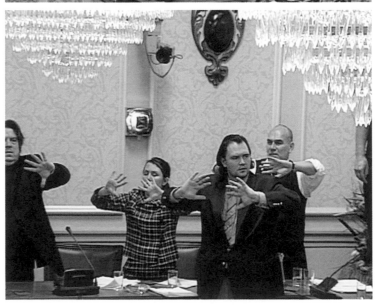

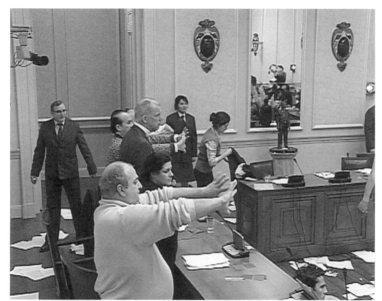

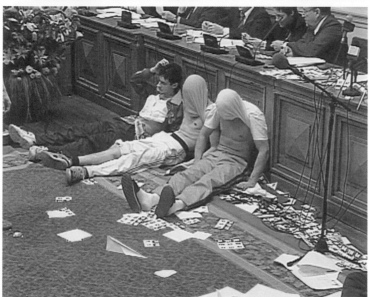

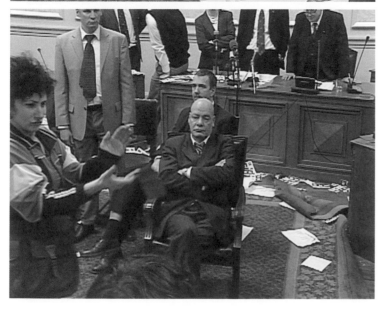

RAW FOOTAGE

2006
Two-channel video installation (color, sound), looped
Images from found documentary material available from Reuters and ITN, ITN Source
Courtesy carlier | gebauer, Berlin

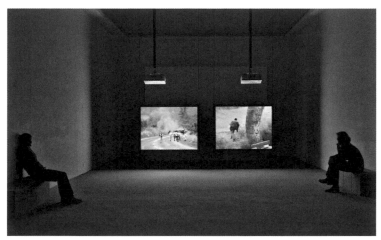

Installation view at Kunstverein Hannover, 2007–08

Raw Footage marks a turn in Mik's approach to film. Instead of devising scenarios and shooting the imagery himself, the artist used material from newsreels documenting the civil war in Yugoslavia. Mik culled his edited sequences from discarded footage that was never included in news broadcasts because it was deemed insignificant or not dramatic enough. The two-channel work often pairs related subjects on side-by-side screens. Mik groups these remnants around similar events or themes and divides them into short chapters by inserting ten seconds of black screen between them. Sometimes only the right or left screen is used so that the viewer's attention focuses for a moment on a single image.

Some chapters show soldiers loading their guns and firing their weapons, while other segments reveal soldiers' off-duty hours as they nap or listen to music. Mik's editing highlights the parallel existence of agricultural work and warfare, and the slippage between civilian life and military duty. Mundane, daily events coexist with elements of war (a jogger cruises by bombed out buildings, people casually walk around as houses burn in the distance). Some of the most poignant images feature animals that have simply adapted to their new circumstances: a goat scavenges for food; a dog seeks attention from soldiers who are busy loading their guns; a sheep stands patiently behind a line-up of troops. Children, on the other hand, seem to have a keen understanding of the conflict, as seen in images of school-age boys playing with toy rifles and discarded military equipment.

Raw Footage retains the sound from the original news tapes. Aside from the occasional crescendo of gunfire or warning sirens, most of the audio is unintelligible. But in one audible fragment, a soldier pleads with a cameraman who tries to record saleable footage for the news outlets: "Just leave this place," he repeatedly begs. As a reporter stands in front of a moving tank in defiance of the warning, the soldier continues, "We have to do something, we have to go somewhere."
—*KS*

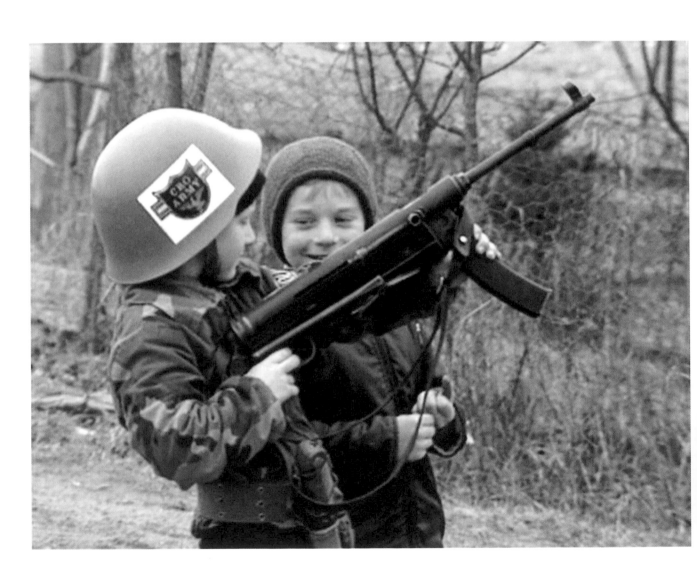

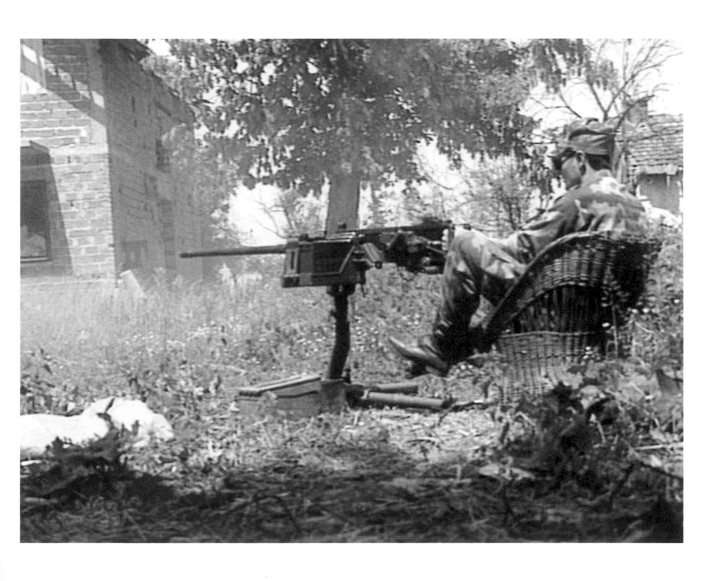

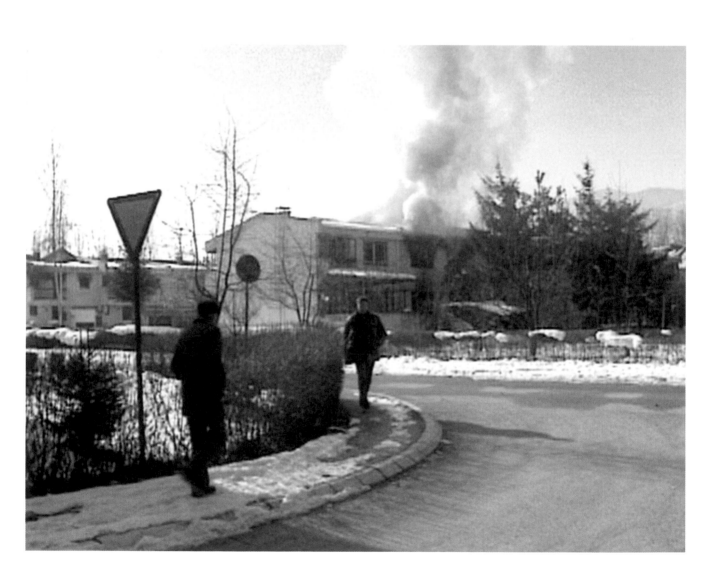

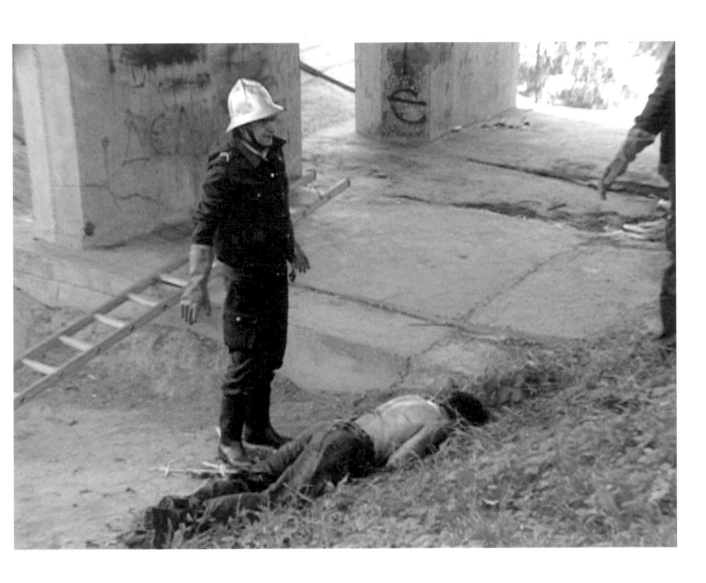

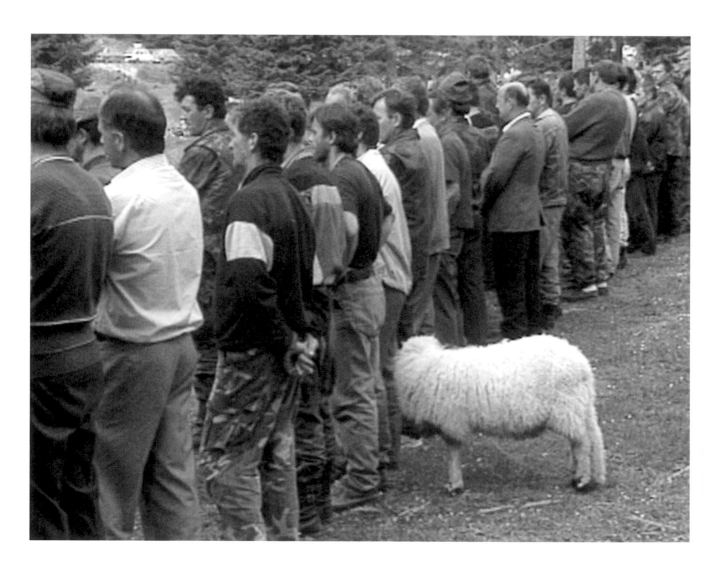

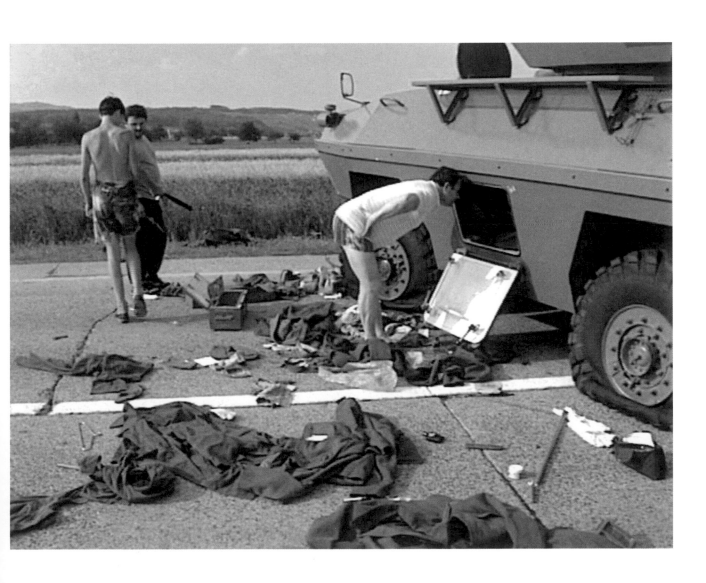

scapegoat. Free standing screen on floor elevators.

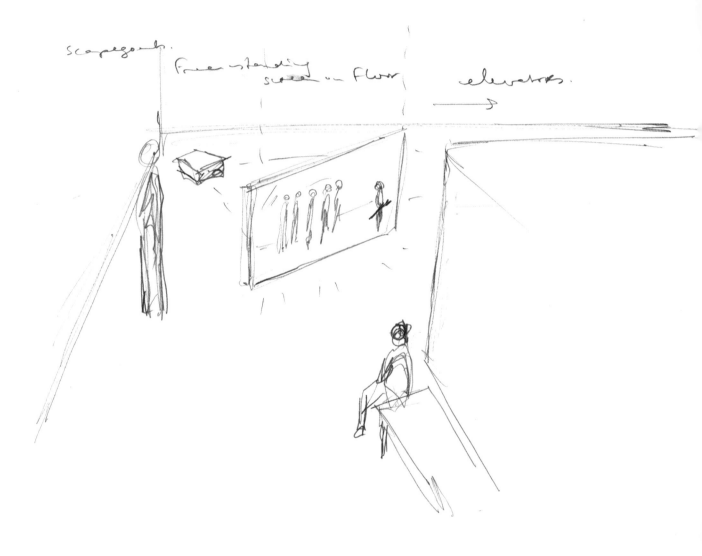

SCAPEGOATS

2006
Single-channel video installation (color, silent), looped
Free-standing screen
Courtesy carlier | gebauer, Berlin

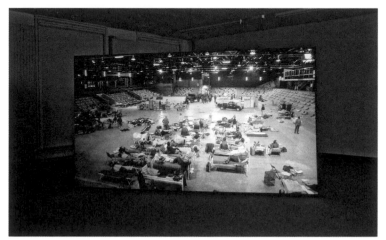

Installation view at BAK, basis voor actuele kunst, Utrecht, 2006

Scapegoats is set in and around an unspecified sports arena. Most of the action takes place in a large area at the center of the complex, which has been transformed into a refugee camp or holding point of some kind. Stations devoted to different functions—sleeping, cooking, storage, medical care—have been loosely organized into zones. Military operations dominate the entire atmosphere, from the combat trucks parked inside the arena to frequent displays of weaponry. The people inhabiting the scene can be broken down into two groups: those who are in control and those who must follow orders. Commanders continually line up their charges, only sometimes allowing them to rest on the ground with their hands on their heads. An adolescent boy is given the responsibility of carrying a rifle as he patrols a group of detainees. At the same time, more prosaic scenes unfold: a portable stove and café tables form a makeshift canteen, and cots provide a place to rest.

The divisions and allegiances among the groups remain tenuous. The captors wear military-oriented garb, but the ragtag nature of their clothes does not belie any particular political leaning or nationality. The visual similarities between all of the factions—soldiers, prisoners in uniform, and those who are partially dressed in both civilian and military attire—further the confusion and make it impossible to place people into distinct categories. Nor is it clear if the "prisoners" may actually be dangerous. The aggressors instigate frequent movement, making their enemies line up, sit down, march, and move to the exterior of the building, where they continue to shove, kick, and reprimand. At one point, there is a sudden reversal of roles and the captives temporarily take over. As the film continues on a loop, the guns always seem just a moment from firing.
—KS

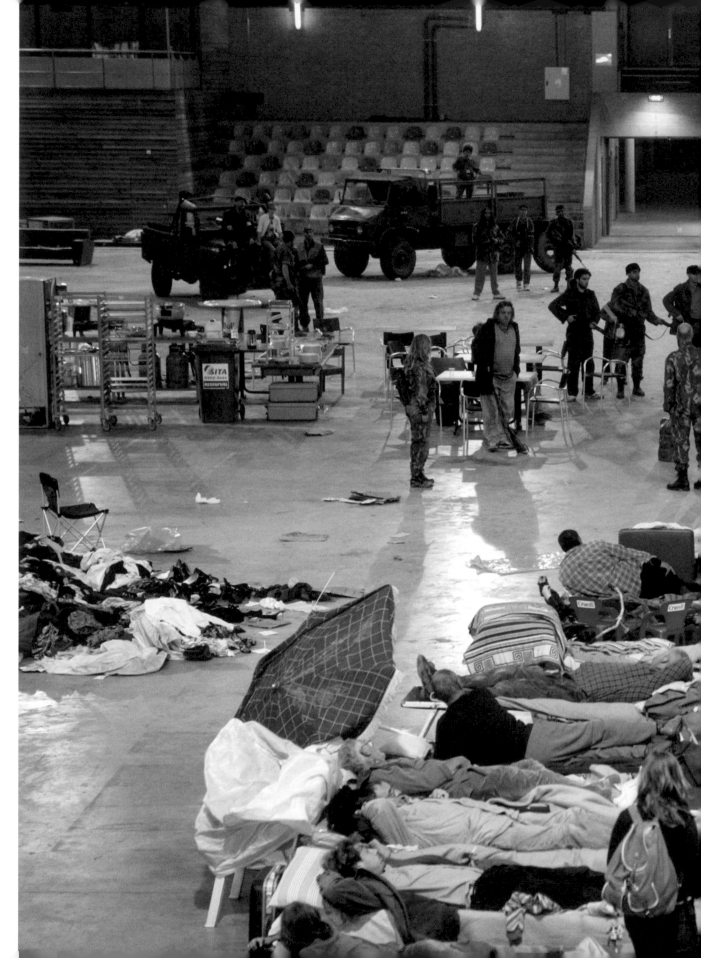

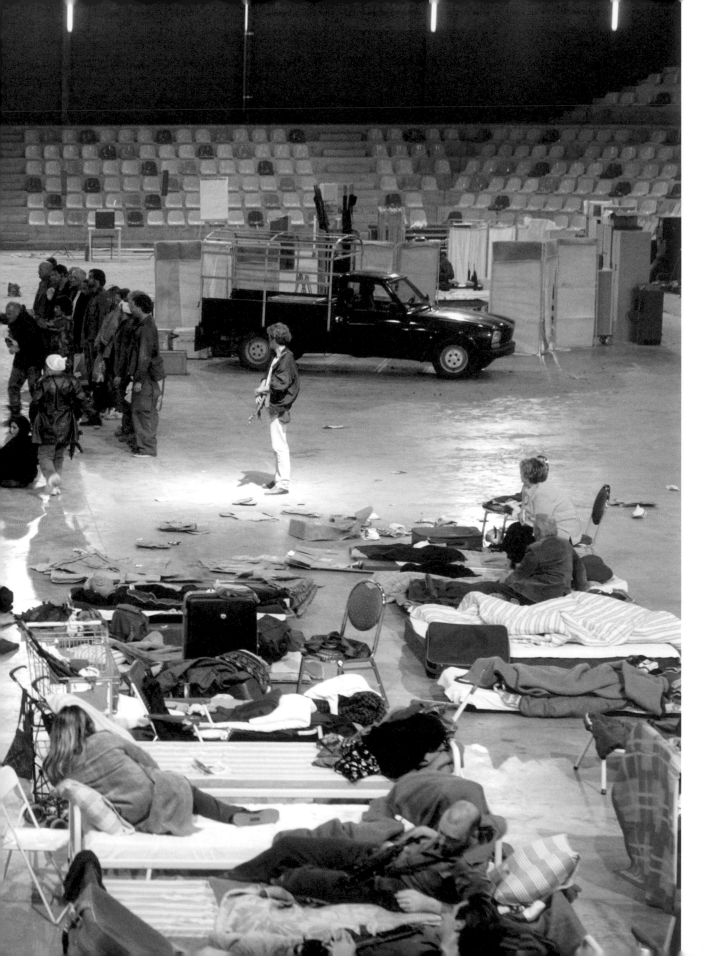

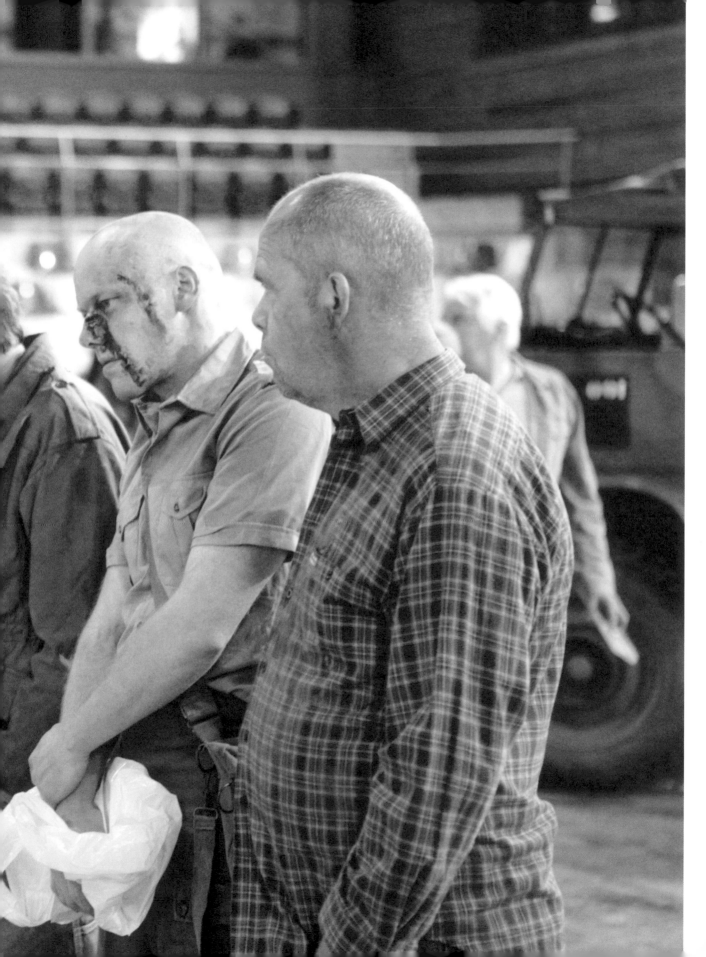

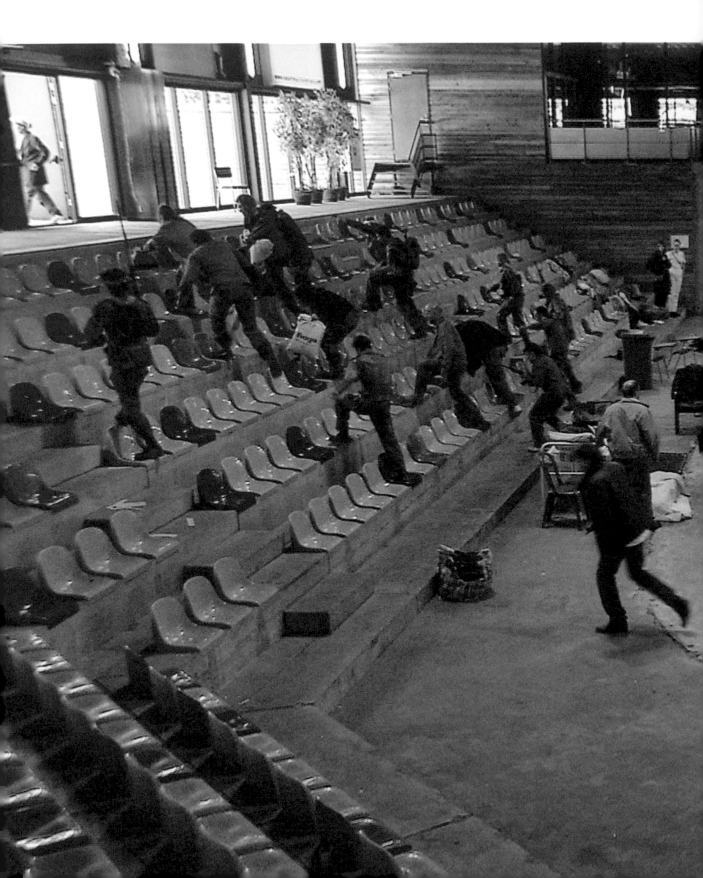

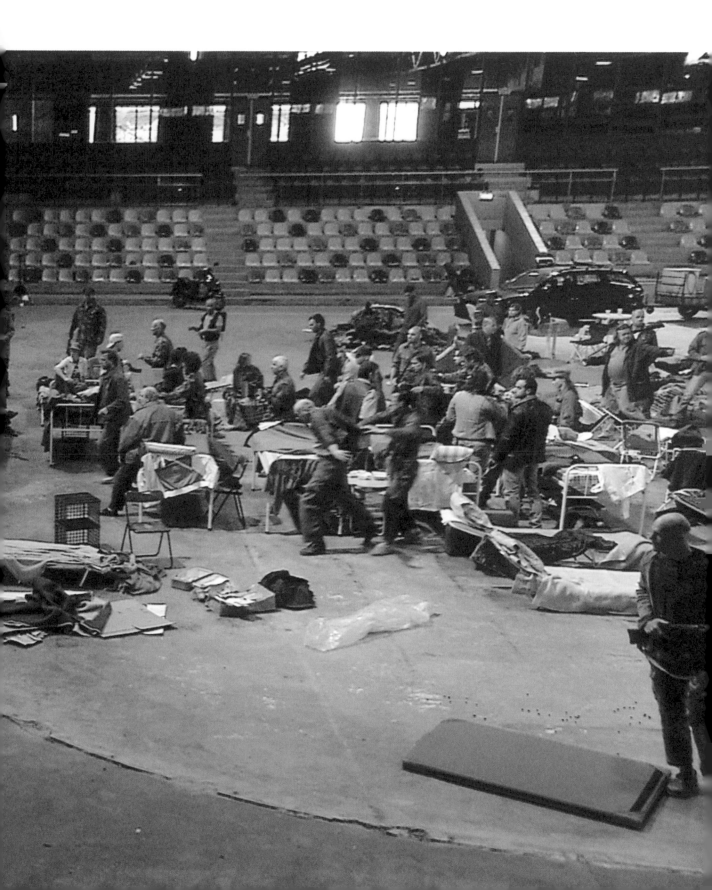

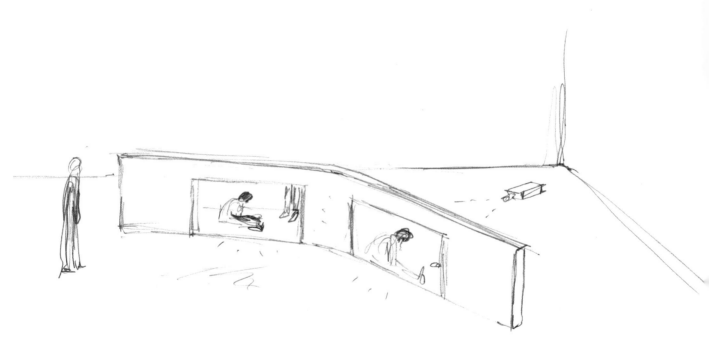

TRAINING GROUND

2006
Two-channel video installation (color, silent), looped
Two rear-projection screens, one free-standing and one embedded in temporary architecture
Courtesy carlier | gebauer, Berlin, and The Project, New York

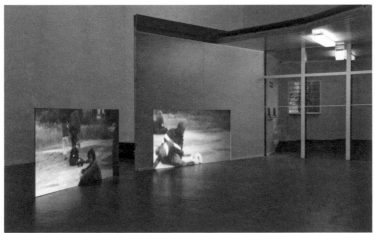

Installation view at Venice Biennale, Dutch Pavilion, 2007

Training Ground portrays uniformed guards running through
field exercises that teach them how to detain people. The guards
try to force their captives into immobile positions by making
them sit or lie on the ground. As the maneuvers unfold,
however, some of the police personnel squat on the pavement
with the original detainees. Furthering this role reversal, some
captives begin to dominate their own kind, creating confusion
about who is in control. Both groups begin to look dazed
and unstable as some people enter into trances. In particular,
a blonde female guard seems to be in a state of possession as
she drools and stares blankly into space. Her actions mirror a
black captive who slobbers as he crawls through the dirt. Later,
this man takes up two wooden rifles and marches as if he were
on patrol, but his faux weaponry and tracksuit give him away as
an imposter. In another scene, a captive points his fake gun at a
fellow prisoner who crouches down. The division between those
in power and those who submit becomes blurred and reversible.
Who belongs to which group? Who can perform specific
actions? Even seemingly simple categorizations remain unclear.
—*KS*

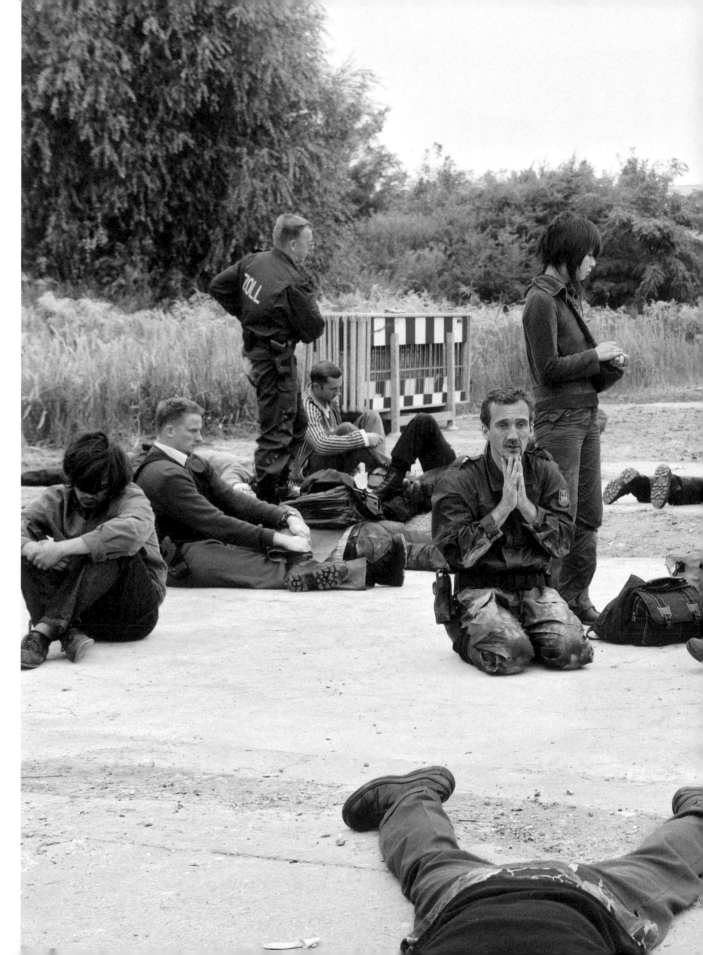

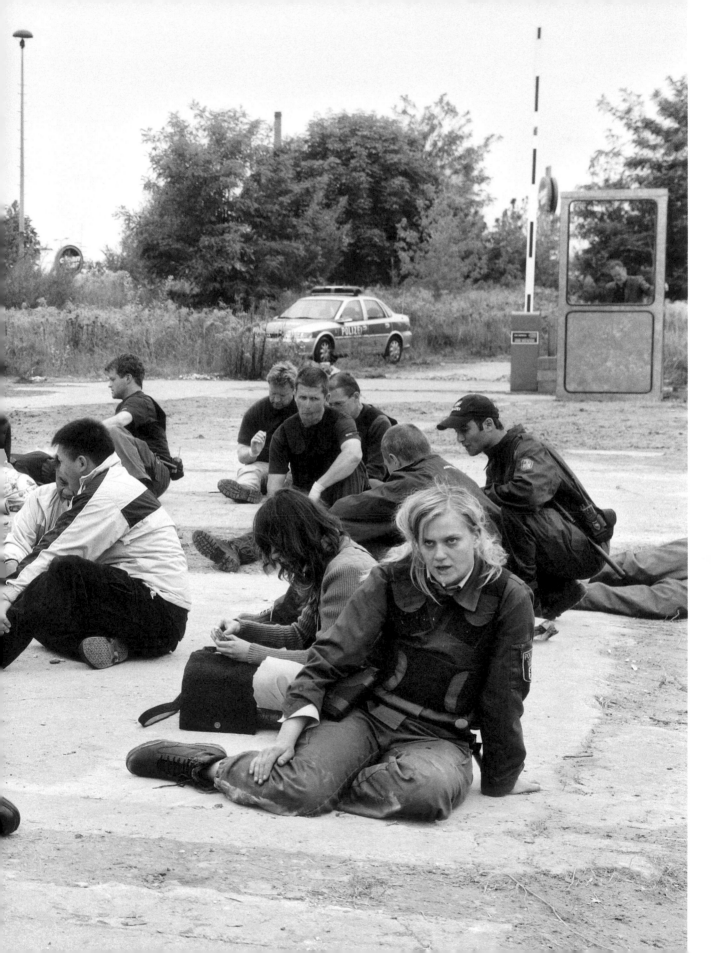

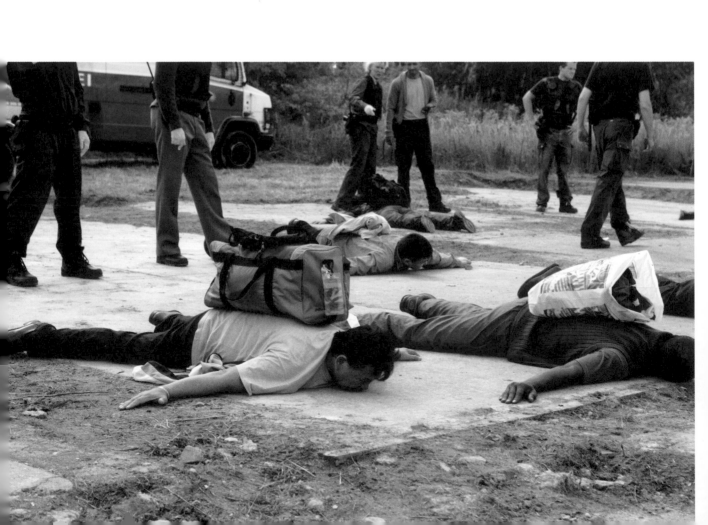

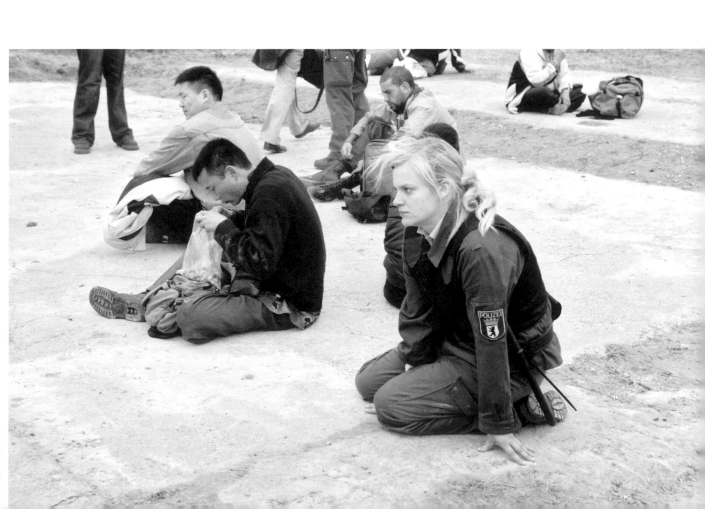

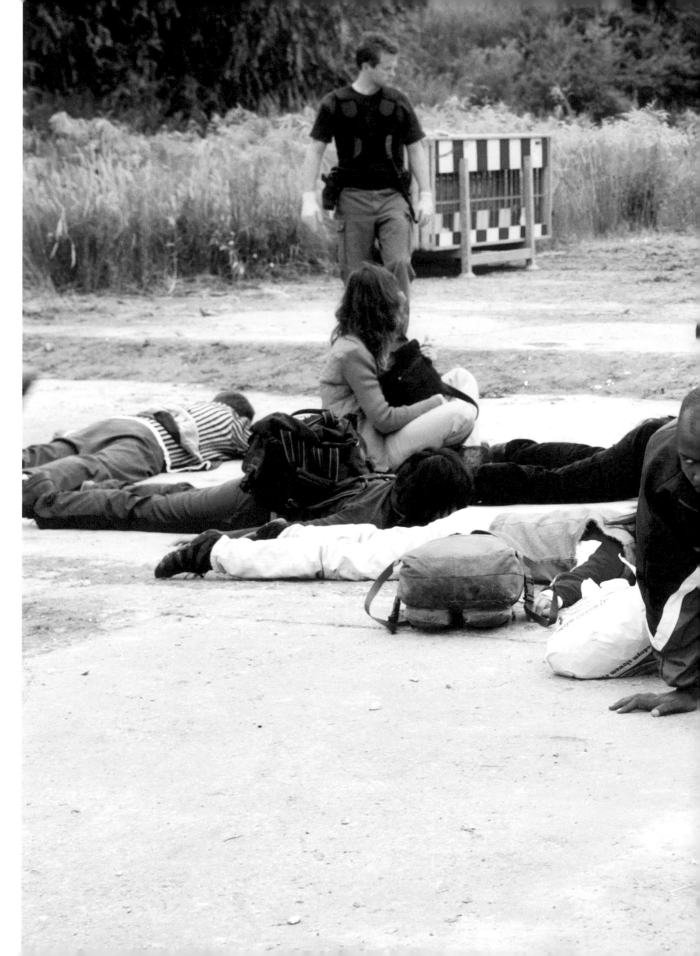

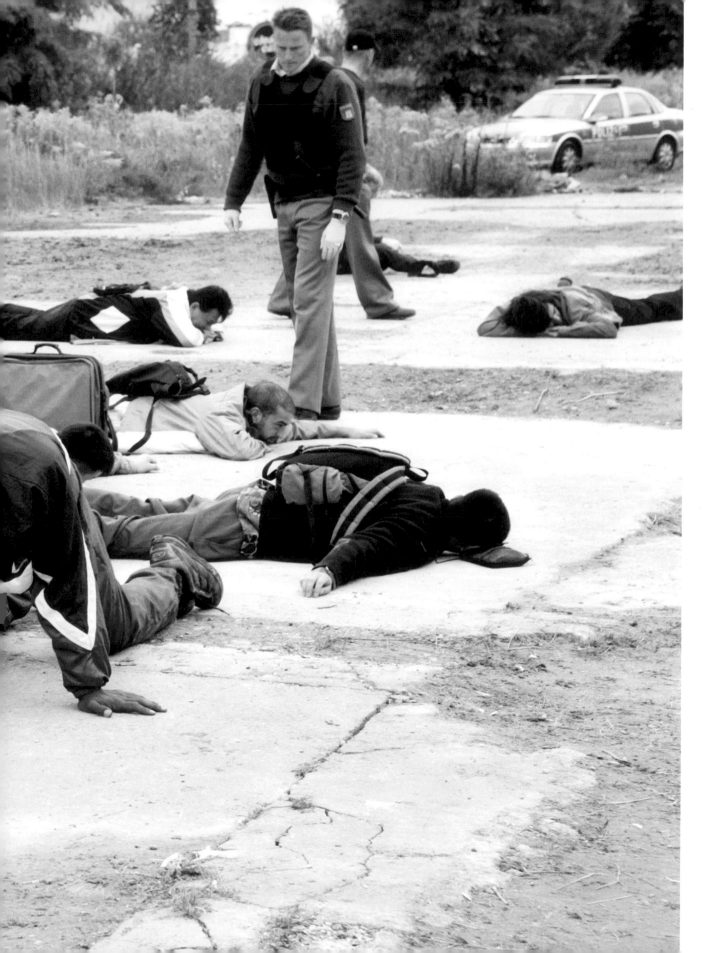

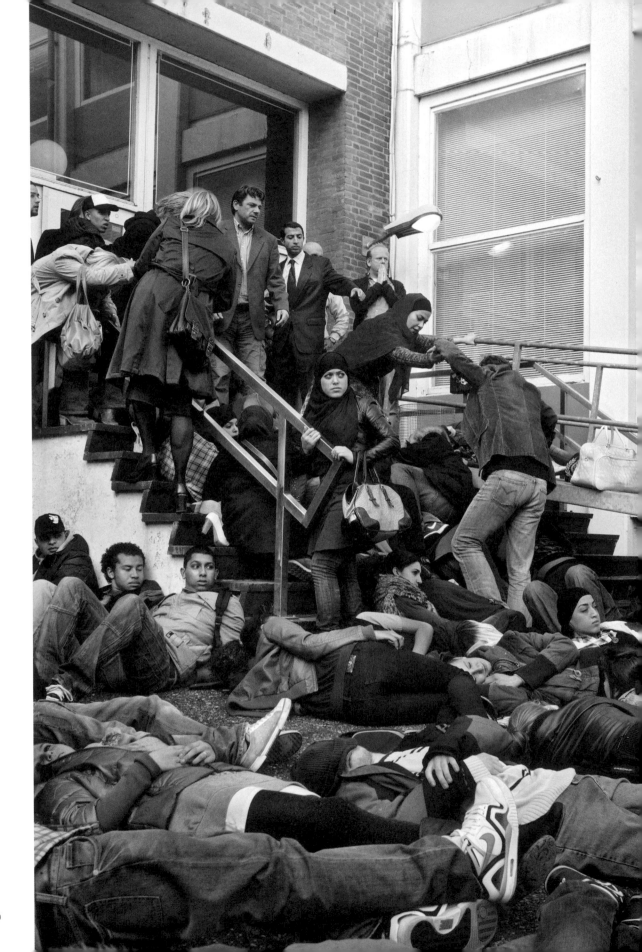

SCHOOLYARD

2009
Two-channel video installation (color, silent), looped
Courtesy carlier | gebauer, Berlin

At a vocational high school in The Netherlands, people mill around a schoolyard after the building has been evacuated for an unspecified reason. As they await permission to reenter, groups begin to form. Teachers, security personnel, and students of various ethnic backgrounds—including Dutch, Turkish, Surinamese, and Moroccan—loosely congregate in the open space. The adolescents evince a characteristic mixture of boredom, insecurity, and bravura. Some people shield themselves with headscarves, caps, and hooded jackets.

Seemingly innocent acts of teasing and aggression bubble up between individuals and larger groups, with some of these outbursts escalating into more intense clashes. Various processions of people either celebrate ecstatically or mourn together. One group carries a prostrate human body in the air, while another hoists up a dummy in effigy. At one point a car with an open sunroof becomes the focus of the crowd as youngsters and teachers clamor to crawl inside and stand on top of it. As these moments of discord and exuberance erupt in brief flashes and then just as quickly subside, the schoolyard continues to function as a place where people casually gather. From the mundane to the excessive, the result of this fluid shift between normal and extreme behavior suggests a community at once orderly and unsettled.

—*KS*

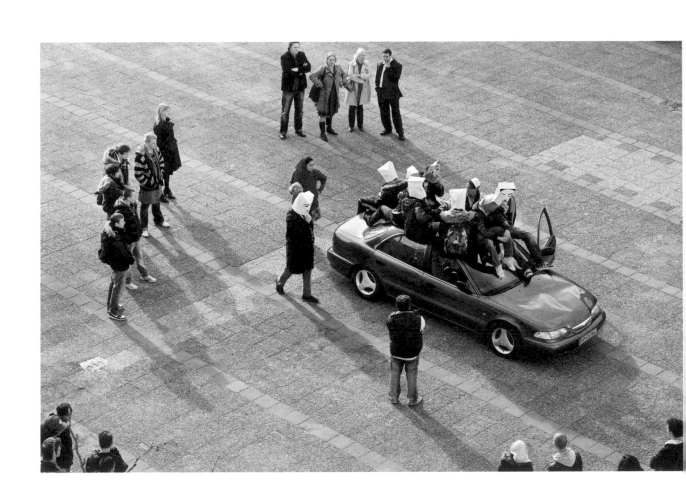

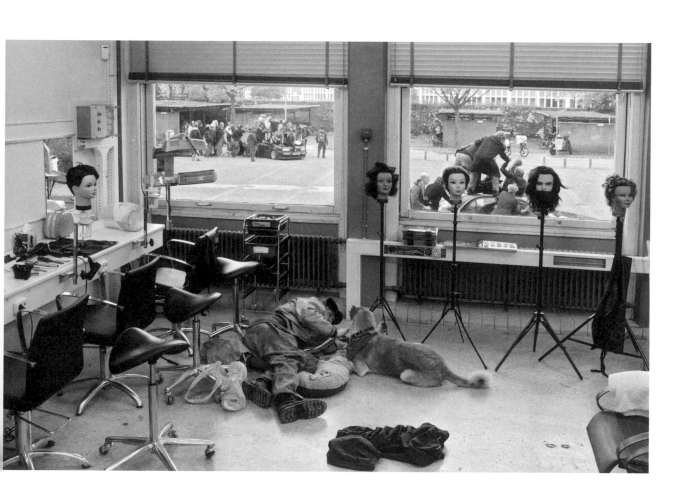

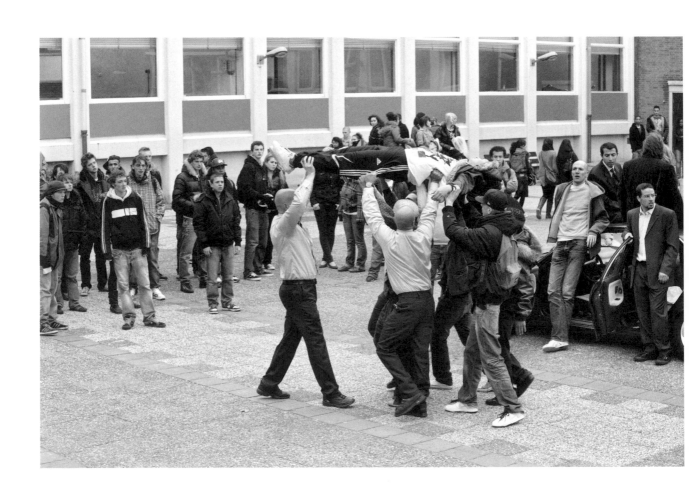

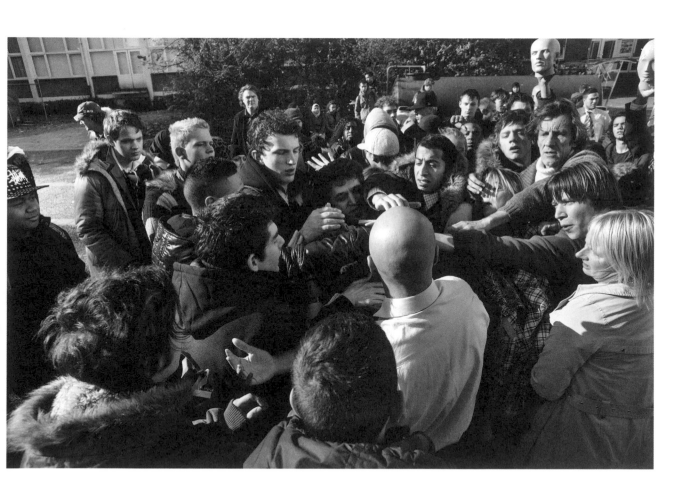

EXHIBITION HISTORY

AERNOUT MIK

Born 1962 in Groningen, The Netherlands
Lives and works in Amsterdam

Education
1987–88 Ateliers '63, Haarlem, The Netherlands
1983–88 Academie Minerva, Groningen, The Netherlands

SELECTED EXHIBITIONS

SOLO EXHIBITIONS

2009
carlier | gebauer, Berlin
The Museum of Modern Art, New York

2008
Kunstpreis Aachen 2008. Ludwig Forum für Internationale Kunst,
 Aachen, Germany
Moderna Galerija, Ljubljana

2007
Aernout Mik: Shifting Shifting. Camden Arts Centre, London. Traveled to:
 Fruitmarket Gallery, Edinburgh; Bergen Kunsthall, Norway;
 Kunstverein Hannover
Aernout Mik: Training Ground. World Class Boxing, Miami
Dutch Pavilion, Venice Biennale

2006
Aernout Mik: Osmosis and Excess. Kunstmuseum Thun, Switzerland
Aernout Mik: Raw Footage/Scapegoats. BAK, basis voor actuele kunst,
 Utrecht
Galleria Civica di Arte Contemporanea, Trento, Italy
Refraction. Galleria Massimo De Carlo, Milan

2005
Aernout Mik: Refraction. New Museum of Contemporary Art, New York.
 Traveled to: Museum of Contemporary Art, Chicago; Hammer
 Museum, Los Angeles
Aernout Mik: Vacuum Room. Centre pour l'image contemporaine, Geneva.
 Traveled to: Argos, Brussels; MC Kunst, Los Angeles; carlier |
 gebauer, Berlin

2004
Aernout Mik: Dispersions. Haus der Kunst, Munich

Aernout Mik: Reversal Room. Herbert F. Johnson Museum of Art, Cornell
 University, Ithaca, New York
Dispersion Room. Museum Ludwig, Cologne
Parallel Corner. The Project, New York

2003
Aernout Mik: Flock. Magasin 3 Stockholm Konsthall
Aernout Mik: Project 244. The Cleveland Museum of Art
BildMuseet, Umeå Universitet, Sweden
CaixaForum, Fundación "la Caixa", Barcelona. Traveled to: Museo de la
 Pasión, Valladolid, Spain, and Les Abattoirs, Toulouse
Frac Champagne-Ardenne, Reims
In Two Minds. Stedelijk Museum, Amsterdam
Pori Art Museum, Finland
The Project, Los Angeles
Pulverous. carlier | gebauer, Berlin

2002
Aernout Mik. Fundació Joan Miró, Barcelona
AM in the LAM. The Living Art Museum, Reykjavík
Contemporary Art Center, Vilnius
Flock. Galleria Massimo De Carlo, Milan
Reversal Room. Stedelijk Museum Bureau Amsterdam

2001
Domaine de Kerguéhennec, Centre d'art Contemporain, Bignan, France
Middlemen. carlier | gebauer, Berlin
The Power Plant Contemporary Art Gallery, Toronto

2000
Aernout Mik: Primal Gestures, Minor Roles. Stedelijk Van Abbemuseum,
 Eindhoven, The Netherlands
Simulantengang. Kasseler Kunstverein, Kassel, Germany
Tender Habitat: Three Works by Aernout Mik. Jean Paul Slusser Gallery,
 University of Michigan, Ann Arbor
3 Crowds. Institute of Contemporary Arts, London

1999
Piñata. Deweer Art Gallery, Otegem, Belgium
Projektraum, Hanging Around: Aernout Mik. Museum Ludwig, Cologne
Small Disasters. Galerie Fons Welters, Amsterdam
Softer Catwalk in Collapsing Rooms. Galerie Gebauer, Berlin

1998
Galerie Index, Stockholm

1995
Mommy, I Am Sorry (with Adam Kalkin). De Vleeshal, Middelburg,
 The Netherlands
Stuffed, Weak and Filthy. Deweer Art Gallery, Otegem, Belgium
Wie die Räume gefüllt werden müssen. Kunstverein Hannover

1993
Unfair. Galerie Fons Welters, Art Cologne, Cologne

1992

Für nichts und wieder nichts. Deweer Art Gallery, Otegem, Belgium

The Philosophy of Furniture (with Adam Kalkin). Galerie Fons Welters, Amsterdam

1990

Voorwerk. Witte de With Center for Contemporary Art, Rotterdam

GROUP EXHIBITIONS

2008

Art, Price, and Value. Contemporary Art and the Market. Centre for Contemporary Culture Strozzina, Palazzo Strozzina, Florence

East of Eden: A Garden Show. Zentrum Paul Klee, Bern

Glück – Welches Glück. Deutsches Hygiene-Museum, Dresden

Land Wars. Te Tuhi Centre for the Arts, Manukau City, New Zealand

Peripheral Vision and Collective Body. Museion, Bolzano, Italy

The Prehistory of Crisis. Project Arts Centre, Dublin

Prospect.1 New Orleans

Short Stories in Contemporary Photography. Museum für Gestaltung, Zurich

The Subject Now. Adam Art Gallery, Victoria University of Wellington, New Zealand

The Tree: From the Sublime to the Social. Vancouver Art Gallery

Trio: Minerva Cuevas, Aernout Mik, Mladen Stilnović. Stedelijk Van Abbemuseum, Eindhoven, The Netherlands

Working Men: Contemporary Art and Work. Galerie Alalix Forever, Geneva

2007

The Art of Growing Old. ar/ge kunst, Galerie Museum, Bolzano, Italy

Contour/Continuïteit, Heden en Verleden. Stedelijk Museum Het Prinsenhof, Delft, The Netherlands

Eyes Wide Open: Aanwinsten Stedelijk Museum and The Monique Zajfer Collection. Stedelijk Museum, Amsterdam

Free Electrons: Works from the Lemaitre Collection. Tabacalera International Contemporary Culture Center of San Sebastian, Spain

Her(his)tory. The Nicolas P. Goulandris Foundation Museum of Cycladic Art, Athens

Passage du Temps: Collection François Pinault Foundation. Tri Postal, Lille

Schmerz. Hamburger Bahnhof, Museum für Gegenwart, Berlin

Von Bill Viola bis Aernout Mik: Werke aus der Sammlung der Nationalgalerie. Hamburger Bahnhof, Museum für Gegenwart, Berlin

2006

Aanwinsten hedendaagse kunst: "The Alter" van Damien Hirst, de foto "Xteriors XII" van Desiree Dolron en de video-installatie "Osmosis and Excess" van Aernout Mik. Centraal Museum, Utrecht

Art Unlimited. Art Basel, Switzerland

Bin Beschäftigt. Gesellschaft für Aktuelle Kunst, Bremen, Germany

News: Recent Acquisitions in Contemporary Art. The Israel Museum, Jerusalem

Other Rooms, Other Voices: Contemporary Art from the Frac Collection. The Israel Museum, Jerusalem

Post-modelism. Bergen Kunsthall, Norway

A Short History of Performance – Part IV. Whitechapel Art Gallery, London

Sip My Ocean: International Video in the Louisiana Collection. Louisiana Museum of Modern Art, Humlebaek, Denmark

Sonambiente Festival für Hören und Sehen, Berlin

Stedelijk Museum De Lakenhal, Leiden, The Netherlands

This Is America: Visions of the American Dream. Centraal Museum, Utrecht

Under the Skin. UniversalStudios-Beijing (aka Boers-Li Gallery), Beijing

2005

Arbeithaus Einatmen. Ausatmen. Kunsthaus Dresden

Concerning War – Soft Target. War as a Daily, First-hand Reality. BAK, basis voor actuele kunst, Utrecht

The Gravity in Art. De Appel Arts Centre, Amsterdam

InSite_05: Interventions and Scenarios. San Diego, California, and Tijuana, Mexico

Irreducible: Contemporary Short Form Video. California College of the Arts, Wattis Institute for Contemporary Arts, San Francisco. Traveled to: Miami Art Central; The Bronx Museum of the Arts

Multiple Räume (2): Park. Staatliche Kunsthalle Baden-Baden, Germany

Pursuit of Happiness. Bureau Beyond, Utrecht

Roaming Memories. Ludwig Forum, Aachen, Germany

Slow Art: Contemporary Art from The Netherlands and Flanders. Museum Kunst Palast, Düsseldorf

Trial of Power. Künstlerhaus Bethanien, Berlin

Vom Verschwinden. Weltverluste und Weltfluchten. Phoenix Halle, Dortmund-Hörde, Germany

Whatever Happened to Social Democracy? Rooseum Center for Contemporary Art, Malmö, Sweden

2004

Célebration! 20 ans du Frac Champagne-Ardenne. Jeff Wall/Aernout Mik. La Chapelle, Ancien Collège des Jésuites, Reims

A City Called Ambition: Kimsooja, Aernout Mik, Paul Pfeiffer. The Project, Los Angeles

Dass die Körper sprechen, auch das wissen wir seit langem/That Bodies Speak Has Been Known for a Long Time. Generali Foundation, Vienna

Die Zehn Gebote: eine Kunstausstellung. Deutsches Hygiene-Museum, Dresden

Doubtful – Dans les plis du reel. Galerie Art & Essai, Université Rennes, France

Dwellen: Exhibition of Contemporary Video Art. Charlottenborg Exhibition Hall, Copenhagen

Fade In: New Film and Video. Contemporary Arts Museum, Houston

Firewall. Ausstellunghalle zeitgenössische Kunst Münster. Traveled to: Würtembergischer Kunstverein Stuttgart

Nunca supe si lo que me contabas era cierto o producto de tu fantasia. Galeria Estrany – De La Mota, Barcelona

São Paulo Bienal

Suburban House Kit. Deitch Projects, New York

This Much Is Certain. Royal College of Art Galleries, London

Videodreams: Between the Cinematic and the Theatrical. Kunsthaus Graz, Austria

Who If Not We...? Surfacing. Ludwig Museum Budapest – Museum of
Contemporary Art

World Wide Video Festival. Amsterdam

2003

Art Focus 4: International Biennial of Contemporary Art. Museum of the
Underground Prisoners, Jerusalem

Die Realität der Bilder – Zeitgenössische Kunst aus den Niederlanden.
Staatliches Museum Schwerin, Germany. Traveled to: Stadtgalerie
Kiel, Germany

Europe Exists. Macedonian Museum of Contemporary Art, Thessaloniki

Fast Forward: Media Art, Sammlung Goetz. Zentrum für Kunst und
Medientechnologie, Karlsruhe, Germany

In or Out: Contemporary Art from The Netherlands. National Museum of
Contemporary Art, Seoul

The International Video Art Festival. State Hermitage Museum and State
Russian Museum, St. Petersburg

Istanbul Biennial

Micropolíticas: Arte y Cotidianidad (2001–1968). Part I. Espai d'art
contemporani de Castelló, Spain

Musée d'Art Contemporain, Marseille

OUTLOOK International Art Exhibition. Athens

Rencontres Vidéo Art Plastique 2003. Wharf, Centre d'art contemporain
de Basse-Normandie, Hérouville Saint-Clair, France

Rituale. Akademie der Künste, Berlin

Samsenscholing van werken uit de collectie van het Centraal Museum.
Centraal Museum, Utrecht

Silent Wandering. Postbahnhof am Ostbahnhof, Berlin

Taktiken des Ego. Foundation Wilhelm Lehmbruck Museum, Center
of International Sculpture, Duisburg, Germany

Trésors Publics: 20 ans des Frac en France. Lieu Unique, Nantes, France

Turbulence. CAC, Kiev, and Museum voor Moderne Kunst Arnhem,
The Netherlands

Zones. Art Gallery of Hamilton, Ontario

2002

Ce qui arrive. Fondation Cartier pour l'art contemporain, Paris

Commitment. Fonds voor Beeldende Kunsten, Vormgeving en Bouwkunst,
Amsterdam

Das Museum, die Sammlung, der Direktor und seine Liebschaften. Museum
für Moderne Kunst, Frankfurt

Geld und Wert - Das letzte Tabu. EXPO 02, Biel, Switzerland

Récits. Abbaye Saint-André, Centre d'art contemporain de Meymac, France

Stories: Erzählstrukturen in Der Zeitgenössischen Kunst. Haus der Kunst,
Munich

Tableaux Vivants: Lebende Bilder und Attitüden in Fotografie, Film und Video.
Kunsthalle Wien, Vienna

Xenophile. MAMCO, Geneva

2001

Blue Moon Festival. Groninger Museum, Groningen, The Netherlands

Boxer. Kunsthalle Tirol, Hall, Austria

Exploding Cinema/Cinema Without Walls. Museum Boijmans Van
Beuningen, Rotterdam

Futureland. Städtisches Museum Abteiberg, Mönchengladbach, Germany,
and Museum van Bommel van Dam, Venlo, The Netherlands

Loop: Alles auf Anfang. Kunsthalle der Hypo-Kulturstiftung, Munich.
Traveled to: P.S.1 Contemporary Art Center, Long Island City, New York

Moving Pictures: 5th International Photo Triennial. Esslingen, Germany

The People's Art/A Arte do Povo: 20 Dutch Artists. Porto 2001, Central
Eléctrica do Freixo, Porto. Traveled to: Witte de With Center for
Contemporary Art, Rotterdam

Post-Nature: Nine Dutch Artists. Ca' Zenobio, Venice Biennale. Traveled to:
Instituto Tomie Ohtake, São Paulo

2nd Berlin Biennial

Squatters/Ocupações. Museu Serralves, Porto

Toegepast. Centraal Museum, Utrecht

WonderWorld. Kleines Helmhaus, Zurich

Yokohama 2001: International Triennale of Contemporary Art

Zero Gravity: Art, Technology, and New Spaces of Identity. Fondazione
Adriano Olivetti, Palazzo delle Esposizioni, Rome

2000

Desperate Optimists. Festival aan de Werf, Huis aan de Werf, Utrecht

Life, after the Squirrel. Location One, New York

*Still/Moving: Contemporary Photography, Film, and Video from The
Netherlands.* National Museum of Modern Art, Kyoto

Territory: Contemporary Art from The Netherlands. Tokyo Opera City
Art Gallery

1999

Ex-tension. Museum Het Domein, Sittard, The Netherlands

EXTRAetORDINAIRE. Le printemps de Cahors. Cahors, France

Glad ijs: overzicht aanwinsten. Stedelijk Museum, Amsterdam

Holland Kindergarten Japan Bondage. De Vleeshal, Middelburg,
The Netherlands

In All the Wrong Places. Ottawa Art Gallery, Ontario

Nur Wasser läßt sich leichter schneiden. Hedrichsmühle, Oevelgönne,
Hamburg

Panorama 2000: Art in Utrecht Seen from the Dom Tower. Centraal Museum,
Utrecht

Post-tragi-KoMik. Palazzo delle Papesse, Contemporary Art Center, Siena

Signs of Life. Melbourne International Biennial

Spread. Galerie Index, Stockholm

Tales of the Tip: Art on Garbage. Organized by Fundament Foundation.
Breda, The Netherlands

A Touch of...Evil. Metrònom, Fundacio Rafael Tous d'Art Contemporani,
Barcelona

1998

Déplacements. Exhibition at Gérard Depardieu's private home, organized
by Galerie Anton Weller, Paris

Do All Oceans Have Walls? Gesellschaft für Aktuelle Kunst, Bremen,
Germany

Going Up the Country. Galerie Fons Welters in Museum De Paviljoens.
Museum De Paviljoens, Almere, The Netherlands

Grown in Frozen Time. Shed im Eisenwerk, Frauenfeld, Switzerland

Ironisch/Ironic. Migros Museum für Gegenwartskunst, Zurich

Lick. Galerie Gebauer, Berlin

Mise en Scène. Grazer Kunstverein, Graz, Austria

NL: Contemporary Art from the Netherlands. Stedelijk Van Abbemuseum, Eindhoven, The Netherlands

No. 41 Sandberg Prizes, 1996–1998: Ritsaert ten Cate, Aernout Mik, Jan Roeland. Stedelijk Museum Bureau Amsterdam

Pictures for the Blue Room. Nordic Institute for Contemporary Art, Helsinki

René Magritte and Contemporary Art. Museum voor Moderne Kunst, Ostend, Belgium

Roommates. Museum Van Loon, Amsterdam

Triple X Festival. Westergasfabriek, Amsterdam

Zomer. Museum De Paviljoens, Almere, The Netherlands

1997

Booster Up Dutch Courage. Third Los Angeles International Biennial

Dutch Pavilion, Venice Biennale

Eté 97. Centre genovois de gravure contemporaine, Geneva

Galerie Anton Weller, Paris

Galerie Fons Welters, Amsterdam

Personal Absurdities. Galerie Gebauer, Berlin

Screen Surface & Narrative Space. The Finnish Museum of Photography, Helsinki

Standort Berlin #1: Places to Stay. BüroFriedrich, Berlin

1996

Abendland: Aernout Mik, Berend Strik, Renée Kool. Stadtmuseum Münster, Germany

Galerie Fons Welters, Amsterdam

Gedraag je! Behave! Benimm dich! Tiens-toi bien! Stedelijk Museum Bureau Amsterdam

ID: An International Survey on the Notion of Identity in Contemporary Art. Stedelijk Van Abbemuseum, Eindhoven, The Netherlands. Under the title *Identite,* traveled to: Le Nouveau Musée, Villeurbanne, France

Making a Place. Newhouse Center for Contemporary Art, Snug Harbor Cultural Center, Staten Island, New York

The Scream: Borealis 8, Nordic Fine Arts 1995–96. Arken Museum of Modern Art, Ishøj, Denmark

Snowball. Deweer Art Gallery, Otegem, Belgium

Take Two. Centraal Museum, Utrecht

Watou Poëziezomer 1996: Wereld je bent een geduldig woord. Watou, Belgium

1995

Galerie Fons Welters, Amsterdam

A Night at the Show. Fields, Zurich

Time. Galerie Fons Welters, Amsterdam

La valise du célibataire/De koffer van de celibatair. Central Railway Station, Maastricht

Wild Walls. Stedelijk Museum, Amsterdam

1994

Galerie Fons Welters, Amsterdam

Het Zevende museum. Stroom Den Haag, The Hague

A Hundred Times. Festival aan de Werf, Utrecht

Ik + De Ander: Art and the Human Condition. Beurs van Berlage, Amsterdam

Spellbound: Inez van Lamsweerde, David Bade, Aernout Mik. Stedelijk Museum Bureau Amsterdam. Traveled to: Centro Cultural de Belém, Lisbon; Asociación Cultural Cruce, Madrid

Swallow. Museum Dhondt-Dhaenens, Deurle, Belgium

1993

De Kracht van Heden. Loods 6, Amsterdam

Peiling 1993. Centraal Museum, Utrecht

Recto/Verso Signalen III. Institute of Contemporary Art, Amsterdam

1992

De Teller en de Noemer, Deconstructieve Beeldstrategieën. Koninklijk Museum voor Schone Kunsten Antwerpen, Antwerp

1991

Ab van Hanegem, Gerald van der Kaap, Aernout Mik, Lidwien van de Ven, Ben Zegers: The Dutch Entry for the Biennale of São Paulo 1991 in collaboration with the Rijksdienst Beeldende Kunst. Stedelijk Van Abbemuseum, Eindhoven, The Netherlands

Double Distance: een tentoonstellig door H. W. Werther. Museum het Kruithuis, 's Hertogenbosch, The Netherlands

Kunst, Europa. Regionalmuseum, Xanten, Germany

Künstlerische Konfrontationen 1991. Torun, Poland

São Paulo Bienal

1990

Capital Gains. Museum Fodor, Amsterdam

Konfrontatie Kunst en Design. Interieur '90, Kortrijk, Belgium

Scanning 1990: Aernout Mik, Berend Strik, Jorgen Leijenaar. Deweer Art Gallery, Otegem, Belgium

1989

Mik-Leijenaar-Strik. Museum het Kruithuis, 's Hertogenbosch, The Netherlands

1988

Capital Gains. Galerie 't Venster, Rotterdam, and De Zaak, Groningen, The Netherlands

Een Grote Activiteit: Niewe generaties in de Nederlandse kunst. Stedelijk Museum, Amsterdam

1987

A Priori Sculptuur. Academy of Architecture, Amsterdam

SELECTED BIBLIOGRAPHY

MONOGRAPHS AND SOLO EXHIBITION CATALOGUES

AC: Aernout Mik: Dispersion Room, Reversal Room. Cologne: Museum Ludwig, 2004. Texts by Gerhard Kolberg and Antje Von Graevenitz.

Aernout Mik. Barcelona: Fundación "la Caixa", 2003. Texts by Dan Cameron and Jorge Wagensberg, and an interview of Aernout Mik by Marta Gili.

Aernout Mik. Otegem, Belgium: Deweer Art Gallery, 1995.

Aernout Mik: Dispersions. Munich: Haus der Kunst, 2004. Texts by Stephanie Rosenthal, Ralph Rugoff, Jim Drobnik, and Jennifer Fisher.

Aernout Mik: Für nichts und wieder nichts. Otegem, Belgium: Deweer Art Gallery, 1992.

Aernout Mik: Primal Gestures, Minor Roles. Eindhoven, The Netherlands: Stedelijk Van Abbemuseum; Rotterdam: NAi Publishers, 2000. Texts by Bernhard Balkenhol, Tijs Goldschmidt, Maxine Kopsa, and Mark Kremer.

Aernout Mik: Refraction. New York: New Museum of Contemporary Art, 2005. Texts by Dan Cameron and Andrea Inselmann.

Aernout Mik: Shifting Shifting. London: Camden Arts Centre, 2007. Text by Michael Taussig.

Aernout Mik: 3 Crowds. London: Institute of Contemporary Arts, 2000. Texts by Martijn van Nieuwenhuyzen and Anne Walsh.

Birnbaum, Daniel. *Aernout Mik: Elastic. How to (Mis)understand Aernout Mik in Twelve Steps.* Amsterdam: Koninklijke Nederlandse Akademie van Wetenschappen, 2002.

Hanging Around. Cologne: Museum Ludwig, 1999. Text by Martijn van Nieuwenhuyzen.

Inselmann, Andrea. *Aernout Mik: Reversal Room.* Ithaca, N.Y.: Herbert F. Johnson Museum of Art, Cornell University, 2004.

Monk, Philip. *Aernout Mik: Reversal Room.* Ontario: The Power Plant Contemporary Art Gallery, 2001.

Walsh, Anne. *Tender Habitat: Three Works by Aernout Mik.* Ann Arbor: Jean Paul Slusser Gallery, University of Michigan, 2000.

BOOKS AND GROUP EXHIBITION CATALOGUES

A Priori Sculptuur. Amsterdam: Makkom Foundation, 1987.

Abendland: Aernout Mik, Berend Strik, Renée Kool. Münster: Städtische Ausstellunghalle Am Hawerkamp, 1996. Text by Rita Kersting.

Aernout Mik, Willem Oorebeek: XLVII Biennale di Venezia Padiglione olandese. Amsterdam: Stedelijk Museum Amsterdam, 1997. Text by Camiel van Winkel.

Biesenbach, Klaus, et al. *Loop: Alles auf Anfang.* Munich: Kunsthalle der Hypo-Kulturstiftung, 2001. Text by Waling Boers.

Booster Up Dutch Courage. Los Angeles: L.A. International Biennial, 1997. Text by Maxine Kopsa.

Braidotti, Rosi, Charles Esche, and Maria Hlavajova, eds. *Citizens and Subjects: The Netherlands, for Example.* Zurich: JRP/Ringier, 2007.

Bussche, Willy Van den, et al. *René Magritte and Contemporary Art.* Ostend, Belgium: Museum voor Moderne Kunst, 1998.

Coelewij, Leontine, and Martijn van Nieuwenhuyzen, eds. *Wild Walls.* Amsterdam: Stedelijk Museum, 1995.

Dass die Körper sprechen, auch das wissen wir seit langem/That Bodies Speak Has Been Known for a Long Time. Vienna: Generali Foundation, 2004. Texts by Hemma Schmutz and Tanja Widmann.

Die Zehn Gebote: eine Kunstausstellung/The Ten Commandments: An Art Exhibition. Dresden: Deutches Hygiene-Museum, 2004.

Do All Oceans Have Walls? Bremen, Germany: Gesellschaft für Aktuelle Kunst, 1998.

Dwellen: Exhibition of Contemporary Video Art. Copenhagen: Charlottenborg Exhibition Hall, 2004.

Een Grote Activiteit: Niewe generaties in de Nederlandse kunst. Amsterdam: Stedelijk Museum, 1988.

Engberg, Juliana, ed. *Signs of Life: Melbourne International Biennial 1999.* Melbourne: City of Melbourne, 1999.

Europe Exists. Thessaloniki: Macedonian Museum of Contemporary Art, 2003.

Firewall. Münster: Ausstellunghalle zeitgenössische Kunst Münster, 2004. Text by Gail B. Kirkpatrick.

Folie, Sabine, and Michael Glasmeier. *Tableaux Vivants: Lebende Bilder und Attitüden in Fotografie, Film und Video.* Vienna: Kunsthalle Wien, 2002.

Goetz, Ingvild, and Stephan Urbaschek, eds. *Fast Forward: Media Art, Sammlung Goetz.* Munich: Kunstverlag Ingvild Goetz, 2003.

ID: An International Survey on the Notion of Identity in Contemporary Art. Eindhoven, The Netherlands: Stedelijk Van Abbemuseum, 1996. Text by Mark Kremer.

Irreducible: Contemporary Short Form Video. San Francisco: California College of the Arts, Wattis Institute for Contemporary Arts, 2005. Texts by Leigh Markopoulos and Ralph Rugoff.

Joachimides, Christos M. *Outlook: International Art Exhibition Athens 2003. Cultural Olympiad.* Athens: Hellenic Culture Organization, 2003.

Kunst, Europa. Mainz: Verlag Hermann Schmidt, 1991.

Mailburg, Barbara, ed. *Futureland.* Mönchengladbach, Germany: Städtisches Museum Abteiberg; Venlo, The Netherlands: Museum van Bommel van Dam, 2001.

Martin, Sylvia. *Video Art.* Cologne: Taschen, 2006.

Micropolíticas: Arte y Cotidianidad. Castellón: Espai d'art contemporani, 2003.

Mise en Scène. Graz, Austria: Grazer Kunstverein, 1998. Text by Eva Maria Stadler.

Morsiani, Paola. *Fade In: New Film and Video.* Houston: Contemporary Arts Museum, 2004.

NL: Contemporary Art from the Netherlands. Eindhoven, The Netherlands: Stedelijk Van Abbemuseum, 1998. Text by Jaap Guldemond.

Pakesch, Peter, ed. *Videodreams: Between the Cinematic and the Theatrical.* Cologne: Verlag der Buchhandlung Walther König and Kunsthaus Graz, 2004.

Passage du Temps: Collection François Pinault Foundation. Milan: Skira, 2007.

Poetic Justice: 8th International Istanbul Biennial. Istanbul: Istanbul Foundation of Culture and Arts, 2003. Text by Dan Cameron.

Post-Nature: Nine Dutch Artists. Eindhoven, The Netherlands: Stedelijk Van Abbemuseum, 2001. Text by Frédéric Paul.

Rush, Michael. *Video Art.* Revised edition. New York: Thames & Hudson, 2007.

Sánchez, Osvaldo, and Donna Cornwell, eds. *inSite_05: Interventions and Scenarios.* San Diego: Installation Gallery, 2006. Texts by Donna Cornwell and Aernout Mik.

The Scream: Borealis 8, Nordic Fine Arts 1995–96. Ishøj, Denmark: Arken Museum of Modern Art, 1996. Text by Kim Levin.

Squatters. Porto: Fundação de Serralves, 2001. Text by Maxine Kopsa.

Still/Moving: Contemporary Photography, Film, and Video from The Netherlands. Kyoto: National Museum of Modern Art, 2000.

Taktiken des Ego/Tactics of the Ego. Duisburg, Germany: Foundation Wilhelm Lehmbruck Museum, Center of International Sculpture, 2003. Texts by Cornelia Brüninghaus-Knubel and Sabine Maria Schmidt.

Territory: Contemporary Art from The Netherlands. Tokyo: Tokyo Opera City Art Gallery, 2000. Text by Kataoka Mami.

This Much Is Certain. London: Royal College of Art, 2004.

The Tree: From the Sublime to the Social. Vancouver: Vancouver Art Gallery, 2008.

Virilio, Paul. *Unknown Quantity.* London: Thames & Hudson, 2003.

Wiehager, Renate, ed. *Moving Pictures.* Ostfildern-Ruit, Germany: Hatje Cantz, 2001.

Yokohama 2001: International Triennale of Contemporary Art. Tokyo: Organizing Commitee for Yokohama Triennale, 2001. Text by Aernout Mik.

Zero Gravity: Art, Technology, and New Spaces of Identity. Rome: Fondazione Adriano Olivetti, 2001. Text by Lorenzo Benedetti.

ARTICLES AND REVIEWS

Ackermann, Tim. "Fortsetzung." *Die Tageszeitung,* December 13, 2007.

Andersson, Patrik. "Aernout Mik: Slow Dance." *Canadian Art* 15, no. 2 (Summer 1998): 72.

Benítez Dueñas, Issa Ma. "Art Basel 34." *Art Nexus,* no. 50 (September–November 2003): 106–09.

Berrebi, Sophie. "Le Printemps de Cahors." *Frieze,* no. 49 (November–December 1999): 113–14.

———. "Rat Race." *Frieze,* no. 52 (May 2000): 90–91.

Birnbaum, Daniel. "Aernout Mik." *Flash Art* 36, no. 228 (January–February 2003): 92.

Bokern, Anneke. "The People's Art: Zeitgenössische Kunst in den Niederlanden." *Kunstforum International,* no. 159 (April–May 2002): 423–24.

Bonet, Rubén. "inSite_05." *Art Nexus* 5, no. 5 (March–May 2006): 68–72.

Borins, Daniel. "Aernout Mik: The Power Plant, Toronto." *Canadian Art* 19, no. 1 (Spring 2002): 102.

Boubounelle, Laurent. "Aernout Mik." *Art Press,* no. 265 (February 2001): 71–72.

Casavecchia, Barbara, Patricia Ellis, and Massimiliano Gioni. "The Old Show." *Flash Art* 33, no. 212 (May–June 2000): 63–65.

Chan, Sewell. "Accident as Art and Artifice." *New York Times,* June 22, 2005.

Connolly, Maeve. "Emporium of the Senses: Spectatorship and Aesthetic Ideology at the 26th São Paulo Bienal." *Third Text* 19, no. 4 (July 2005): 399–409.

Cotter, Holland. "Politics That Makes Peace with the Beauty of Objects." *New York Times,* June 18, 2004.

Crabtree, Amanda. "6th Lyon Biennale." *Art Monthly,* no. 249 (September 2001): 22–24.

Doran, Anne. "Aernout Mik, Refraction." *Time Out New York,* July 27–August 3, 2005, p. 60.

Dorn, Anja. "Hanging Around." *Frieze,* no. 50 (January–February 2000): 104–05.

Drobnick, Jim, and Jennifer Fischer. "Ambient Communities and Association Complexes: Aernout Mik's Awry Socialities." *Parachute,* no. 101 (February 2001): 89–97.

Ellis, Michael. "Aernout Mik." *Art Monthly,* no. 243 (February 2001): 38–40.

Engberg, Juliana. "Dig It." *Art and Australia* 44, no. 4 (Winter 2004): 488–89.

Fenner, Felicity. "New Life in Melbourne." *Art in America* 88, no. 1 (January 2000): 74–77.

Francblin, Catherine. "Aernout Mik, retour au point mort." *Art Press,* no. 290 (May 2003): 40–44.

———. "Lyon: Connivence – 6e Biennale d'Art Contemporain." *Art Press,* no. 272 (October 2001): 74–76.

Frangenberg, Frank. "Aernout Mik." *Kunstforum International,* no. 150 (April–June 2000): 433–34.

Gijsberts, Pieter Jan. "Aernout Mik en Adam Kalkin." *Metropolis M* 14, no. 1 (February 1993): 50.

Grabner, Michelle. "Aernout Mik." *ArtUS,* no. 10 (October–November 2005): 42–43.

Hackett, Sophie. "Aernout Mik: The Power Plant, Toronto." *C Magazine,* no. 72 (Winter 2001–02): 42–43.

Heartney, Eleanor. "Mending the Breach." *Art in America* 91, no. 12 (December 2003): 74–79.

Heather, Rosemary. "Aernout Mik." *Border Crossings* 21, no. 1 (Fall 2002): 77–78.

Heidenreich, Stefan. "Gegner im geschlossenen Raum." *Frankfurter Allgemeine Zeitung,* January 8, 2008.

Hettig, Frank-Alexander. "Adam Kalkin – Aernout Mik: 'The Philosophy of Furniture.'" *Forum International* 4, no. 17 (March–April 1993): 125.

Holert, Tom. "Performing the System." *Artforum* 43, no. 2 (October 2004): 248–52, 303–04.

Jewesbury, Daniel. "Them and Us." *Art Monthly,* no. 248 (July–August 2001): 8–12.

Jocks, Heinz-Norbert. "Aernout Mik: Die Bedrohung von Aussen oder die Simulation einer Simulierten Situation." *Kunstforum International,* no. 188 (October–November 2007): 265–69.

Johnson, Ken. "Art in Review: Aernout Mik." *New York Times,* July 15, 2005.

Jones, Ronald. " 'Whatever Happened to Social Democracy?' Rooseum." *Artforum* 43, no. 10 (Summer 2005): 338–39.

Karcher, Eva. "Aernout Mik: Regeln und Kontrolle sind Gift." *Art Das Kunstmagazin,* no. 10 (October 1995): 72.

Kerr, Merrily. "Aernout Mik." *Time Out New York*, May 27–June 3, 2004, p. 77.

Kitamura, Katie. "Aernout Mik, Reversal Room." *Contemporary*, no. 38 (April 2002): 113.

Klee, Steve. " 'Aernout Mik: *Shifting, Shifting*' at Camden Arts Centre." *Afterall* (February 5, 2008), http://www.afterall.org/onlinearchive. html?online_id=37.

Koplos, Janet. "Laugh Lines." *Art in America* 89, no. 5 (May 2001): 95–97.

Kremer, Mark. "Capital Gains." *De Rijksakademie* 1, no. 3 (1987): 21–23.

———. "Entertainment or het breekbare geloof in een medium." *Kunst & Museumjournaal* 4, no. 2 (1992): 49–53.

———. "The Life of a Repo Man Is Always Intense: Richard Hoeck, Aernout Mik, Joëlle Tuerlinckx: scenario's voor een hernieuwde inbezitneming van de institutionele kunstruimte." *Archis*, no. 6 (1995): 70–80.

———. "De wedergeboorte van het drama." *Kunst & Museumjournaal* 5, no. 2 (1993): 49–52.

———. "Über Aernout Mik. Ein heiterer Nihilist trinkt Orangensaft und isst dazu ein Brownie." *Artist Kunstmagazin* 27, no. 2 (1996).

Kremer, Mark, and Camiel van Winkel. "The Word Art, You Know, Is Not My Primary Interest: Interview with Aernout Mik." *Archis*, no. 1 (1995): 68–74.

Lesák, Franziska. "Aernout Mik: Der dreidimensionale Blick." *Eikon*, no. 30 (1999): 21–25.

Levin, Kim. "Aernout Mik." *Village Voice*, May 26–June 1, 2004.

Lütticken, Sven. "Aernout Mik." *Artforum* 45, no. 7 (March 2007): 334.

Marcelis, Bernard. "Berlin: 2nd Biennale." *Art Press*, no. 270 (July–August 2001): 74–76.

Menin, Samuele, and Valentina Sansone. "Focus Video and Film: Contemporary Video Art Today (Part I)." *Flash Art* 36, no. 228 (January–February 2003): 88–93.

Miles, Christopher. "Aernout Mik, The Project." *Artforum* 41, no. 9 (May 2003): 176.

Myers, Holly. "Human Behavior on Videotape." *Los Angeles Times*, November 5, 2004.

Myers, Terry R. "Aernout Mik: Vacuum Room." *Modern Painters* (November 2005): 109.

Patrick, Keith. "The Century of Fear." *Contemporary*, no. 47 (February 2003): 70–75.

Perra, Daniele. "Aernout Mik." *Tema Celeste*, no. 93 (September–October 2002): 64–67.

Picard, Charmaine. "Art Basel Miami Beach, 2002." *Art Nexus*, no. 48 (April–June 2003): 104–08.

Puvogel, Renate. "Firewall." *Kunstforum International*, no. 172 (September–October 2004): 345–47.

Reininghaus, Alexandra. "Ohne Worte." *Art Das Kunstmagazin*, no. 3 (March 2004): 98.

Roos, Renate. "The Center Holds: Report from the Dutch Art Scene." *Kunstforum International*, no. 143 (January–February 1999): 383–84.

Rosenberg, Angela. "Aernout Mik." *Flash Art* 34, no. 221 (November–December 2001): 87.

———. "Stock-Market: Art and the New Economy." *Flash Art* 34, no. 226 (October 2002): 86–89.

Schambelan, Elizabeth. "Aernout Mik: New Museum of Contemporary Art." *Artforum* 44, no. 2 (October 2005): 272.

Schwabsky, Barry. "Bienal de São Paulo." *Artforum* 43, no. 4 (December 2004): 190.

Seidel, Martin. "Aernout Mik. Dispersion Room." *Kunstforum International*, no. 171 (July–August 2004): 345–46.

Sherwin, Skye. "War: Aernout Mik." *Art Review*, no. 8 (February 2007): 40.

Siegel, Katy. "The Buck Stops Here." *Artforum* 46, no. 1 (September 2007): 389–97.

Smith, Roberta. "Suburban House Kit." *New York Times*, March 12, 2004.

Solans, Piedad. "Intellectualizing Pain." *Lapiz* 26, no. 235 (July 2007): 88–91.

Springer, Jose. "inSite_05, Various Sites Around San Diego and Tijuana." *Flash Art* 39, no. 246 (January–February 2006): 53.

Stoeber, Michael. "Aernout Mik." *Kunstforum*, no. 190 (March–April 2008): 302.

Strange, Reimar. "(T)raumatische Ortsbegehung." *Kunstbulletin Online* (March 2002), http://www.kunstbulletin.ch/router.cfm?a=20020215-103341-431-3.

Ter Braak, Lex. "Willem Oorebeek and Aernout Mik: Reinventing Realities." *Flash Art* 31, no. 203 (November–December 1998): 94–95.

Thatcher, Jennifer. "Aernout Mik: Shifting Shifting." *Art Review*, no. 11 (May 2007): 126.

Thély, Nicolas. "Aernout Mik, vers une chorégraphie du réel." *L'Oeil*, no. 539 (September 2002): 34–35.

"This Is America." *Tema Celeste*, no. 117 (September–October 2006): 107.

Vahland, Kia. "Absurdes Theater ohne Worte." *Art Das Kunstmagazin*, no. 5 (May 2004): 86–88.

Van Den Boogerd, Dominic. "Choreography of Chaos: Aernout Mik's *In Two Minds*." *Parkett*, no. 70 (2004): 134–39.

———. "A State of Uncertainty: Aernout Mik." *Art Papers* 31, no. 5 (September–October 2007): 35–43.

Van Winkel, Camiel. "Aernout Mik and Adam Kalkin: The Philosophy of Furniture." *Archis*, no. 3 (1993): 12–13.

———. "A Gentle Collapsing: Over de attributen van Aernout Mik." *Metropolis M* 13, no. 1 (February 1992): 28–31.

Visinet, Arnauld. "Déplacements." *Art Press*, no. 244 (March 1999): 84–86.

Wampler, Liberty. "Feeding into the Loop." *City Beat* (Cincinnati), October 17–23, 2002.

Ward, Jeff. "Aernout Mik." *Art Review* 3, no. 10 (October–November 2005): 125.

Wege, Astrid. "Nicht War Wie Es Ist." *Texte zur Kunst* 17, no. 65 (March 2007): 239–42.

Weisbrod, Andrea. "Ce Qui Arrive." *Art Das Kunstmagazin*, no. 3 (March 2003): 93.

Westley, Hester R. "Crossroads: Aernout Mik Interviewed by Hester R. Westley." *Art Monthly*, no. 305 (April 2007): 1–3.

Wetterwald, Élisabeth. "Extraetordinaire. Le Printemps de Cahors." *Parachute*, no. 96 (October–December 1999): 67–68.

Willis, Holly. "Aernout Mik: Refraction." *LA Weekly*, October 18, 2006.

CREDITS

Pp. 28–33
FLUFF
Courtesy the artist and carlier | gebauer, Berlin
Codirection and camera: Marjoleine Boonstra
Color grading: Petro van Leeuwen

Pp. 34–41
MIDDLEMEN
Courtesy the artist and carlier | gebauer, Berlin
Production: Dirk Tolman and Rob Hillenbrink
Codirection: Marjoleine Boonstra
Production design: Rob's Prop Shop
Camera: Benito Strangio
Camera equipment: Cam-a-lot
Casting: Hollands Glorie
Costumes: Sylvia Huijerman
Color grading: Petro van Leeuwen

Pp. 42–49
OSMOSIS AND EXCESS
Courtesy the artist and carlier | gebauer, Berlin
Coproduced with inSite_05, San Diego and Tijuana
Production: Anca Munteanu Rimnic and inSite_05
Codirection: Marjoleine Boonstra
Production design: Elsje de Bruijn. Thanks to: Daniel Martínez, Márga
 de León, Guillerma Parra, Sergio Berry, Edgar Luzanilla, Heriberto
 Luzanilla, Constancio Castillo Toledo, Pablo Maanon, Enrique Guzmán
 Medina, Paco García, Javier Vera, Esmeralda Ceballos, Andre Vázquez,
 Oscar Inzunsa, Montserrat León, Héctor Vázquez "Tito," Sergio Brown,
 Octavio Castellanos, Jesús Efraín García
Camera: Benito Strangio
Color grading: Petro van Leeuwen
Photography on set: Florian Braun

Pp. 50–53
VACUUM ROOM
Courtesy the artist, carlier | gebauer, Berlin, and The Project, New York
Coproduced with Argos, Brussels, and Centre pour l'image contemporaine,
 Geneva
Production: Dirk Tolman, Jelier & Schaaf
Codirection: Marjoleine Boonstra
Production design: Elsje de Bruijn
Camera technique: Jozef Hey, Beamsystems
Casting: Hans Kemna, Kemna Casting
Costumes: Sylvia Huijerman

Pp. 54–61
RAW FOOTAGE

Courtesy the artist and carlier | gebauer, Berlin

Produced by the artist and BAK, basis voor actuele kunst, Utrecht. Realized in partnership with Treaty of Utrecht. Additional support provided by The Netherlands Foundation for Visual Arts, Design and Architecture; Mondriaan Foundation; Galleria Civica di Arte Contemporanea, Trento; and ThuisKopie Fonds and Fentener van Vlissingen Fonds

Images from found documentary material: ITN Source and ITN Source/Reuters

Research: Danila Cahen

Mixing and sound engineering: Hugo Dijkstal

Online: Joke Treffers

Pp. 62–71
SCAPEGOATS

Courtesy the artist and carlier | gebauer, Berlin

Produced by the artist and BAK, basis voor actuele kunst, Utrecht

Additional support provided by The Netherlands Foundation for the Visual Arts, Design and Architecture

Production: Dirk Tolman, Jelier & Schaaf

Codirection: Marjoleine Boonstra

Production design: Elsje de Bruijn

Production manager: Wikke van der Burg

Camera: Benito Strangio

Steady-cam: Jo Vermaercke

Grip: Enterprise

Camera equipment: Cam-a-lot

Casting: Hans Kemna, Kemna Casting

Costumes: Sylvia Huijerman

Makeup: Niels Wahlers

Special effects: Rob's Prop Shop

Weapon handlers and fight instructors: Rik and Harry Wiessenhaan

Postproduction: Loods Lux & Lumen and Beamsystems

Color grading: Petro van Leeuwen

Photography on set: Florian Braun

Pp. 72–79
TRAINING GROUND

Courtesy the artist, carlier | gebauer, Berlin, and The Project, New York

Production: Dirk Tolman, Jelier & Schaaf, Anca Munteanu Rimnic

Codirection: Marjoleine Boonstra

Production design: Elsje de Bruijn

Art department: Josche Allwardt

Steady-cam: Benito Strangio, Jo Vermaercke

Camera equipment: Cam-a-lot

Casting: Anca Munteanu Rimnic

Costumes: Elisabetta Pian

Fight instructor: Rik Wiessenhaan

Color grading: Petro van Leeuwen

Photography on set (pp. 74–79): Florian Braun

Pp. 80–85
SCHOOLYARD

Courtesy the artist and carlier | gebauer, Berlin

Commissioned by The Museum of Modern Art, New York

Additional support provided by The Netherlands Foundation for the Visual Arts, Design and Architecture

Production: Dirk Tolman, Jelier & Schaaf

Codirection: Marjoleine Boonstra

Production design: Elsje de Bruijn

Production manager: Margreet Ploegmakers

Camera: Benito Strangio and Istvan Imreh

Grip: Enterprise

Camera equipment: Cam-a-lot

Casting: Hans Kemna and Betty Post, Kemna Casting

Costumes: Sylvia Huijerman

Makeup: Niels Wahlers

Postproduction: Loods Lux & Lumen

Color grading: Petro van Leeuwen

Photography on set (pp. 4–5, 80, 82–85): Florian Braun